DEFOREST

SENSE OF PSYIGHT

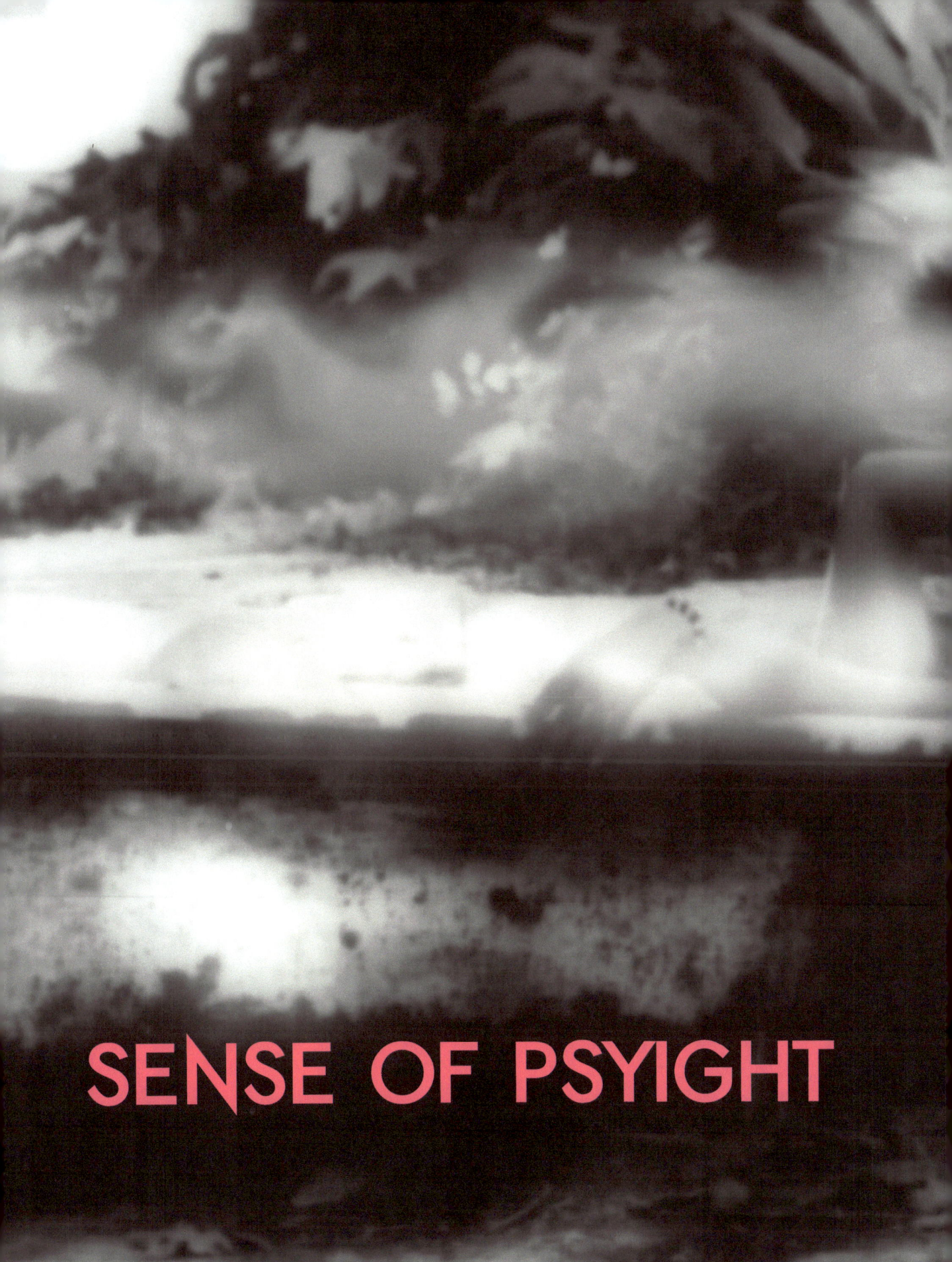

All rights reserved. No part of this book may be used or reproduced in any manner whatsoever without written permission from the publisher except in the case of brief quotations embodied in critical articles or reviews.

For information address SUNFACE ENTERTAINMENT, LLC, info@sunfaceent.com.

Published by SunFace Entertainment, LLC.

ISBN: 978-0615467672

First U.S. Edition 2011

10 9 8 7 6 5 4 3 2 1

Design and layout: http://sunfaceent.com

Follow on Twitter: www.twitter.com/deforestmapp

Follow on Facebook: www.facebook.com/deforestmapp

A portion of proceeds will be donated to a homeless shelter here in Los Angeles.

CONTENTS

FOREWORD	11
DeForest: In his own words "Sense of Psyight"	12
TWO UP / TWO DOWN (VA) -- BIRTH AND DOOR	16
MELROSE & MID WILSHIRE	20
LOOK DOWN' AND SKID LA	30
NATURE, SUN, AND FREEDOM	64
DOWNTOWN NOCTURNAL	76
MEET THE CLOUDS	80
CABIN FEVER -- SNOW IN THE (757)	94

After 27 long years, congratulations mom on a well deserved retirement. May the evolution of your spirit produce a new freedom that will have you jumping rope and playing jacks once again. I love the little girl that is inside of you.

FOREWORD

by CHUKES, The Sculptor

The third eye is said to be some kind of sixth sense. In the case of photographer Deforest Mapp, the third eye is what is seen through the lens of his camera. His lens may be pointed at his subject but his visions come from his mind.

Deforest is a man of many creative skills. As a photographer, actor, filmmaker, architect and musician he combines all of these attributes and pulls from this energy to clearly focus in on his subject matter. There are no second takes or lights, camera action in his photos, just a pure vision of reality in its environment. His job is to take his viewers on a journey into his mind and we see what comes out of his camera.

Deforest allows his viewers to experience in a flash his keen sense of capturing that special moment in time that most of us take for granted. In this fast paced world we live in, how many of us truly take a moment to stop and enjoy the visions and sensations around us?

What is here today may never come back tomorrow. Deforest demonstrates his skillful ability to seek out and photograph the honesty and beauty of a precise moment in time. His images make us aware of just how meaningful our surroundings are. All we need to do is take the time to discover it.

DEFOREST
...from feelings to thoughts to words.

I believe that photography is snatching a still moment out of time. The result of this action inspires the viewer to create a moment-before and a moment-after for his/her self. My hope is that my work will trigger a memory that will in turn cause someone to feel a certain way. If they continue staring at a frozen moment long enough, some aspect of their own life will kick in to play.

Photography and filmmaking are what make up my *"Sense of Psyight"*... the motivation of snatching moments based on thoughts and feelings. I remember falling in love with photography when I was in film school at LACC. My cinematography instructor (in his French accent) told us to go get a 35mm film camera for a few assignments. "If you want to master motion pictures, you must master the still picture... same logic... same rationale." He wanted us to stay away from any digital camera. Within a few days of combing through Craigslist ads, I found my "baby" in Culver City.

I shoot on a 1985 Minolta X-700. She's perfect. I trust her voice. There is something so very excilerating when I touch her...when I load and unload her... when I am advancing her frame. She tells me how many frames are left on our roll... making sure that every single one of our moments together counts toward something special... something meaningful. She understands what I need to see. She keeps it very real with me.

My senses perk up when she and I leave the immediate environment of our home and go out and start exploring. One late afternoon, I was bringing the trash cans in off the street and was stunned with a formation of clouds at sunset. It was powerful. It had this sense of urgency about them. I grab my woman's hand, jump into the car, and we start climbing the hills of the Angeles National Forest.

In five (5) minutes, she and I are high atop Altadena trying to understand what these clouds are trying say to us. I learned then that you just have to take action on the moment that avails itself.

Art and inspiration are all around us. Our lives produce it daily. Sometimes I go into busy corporate districts where I find people who either love or hate what they do for a living. A typical lunch time crowd usually has facial expressions that reflect how they feel about their occupation. The smiles-of-hope or the frowns-of-despair is how I divide a group of everyday individuals who were walking back and forth across the street via the crosswalk. But that crosswalk gives those people the right of way... to hope... to continue... to tolerate... to give up... to compromise... to let go... to reflect... or to change course. I've been there.

Symbiotically, our environment acts as therapy. There is strength in stillness... in quietness. There is the gift of inner peace and happiness that awaits you when you pick up your camera. Listen to God as you walk around. Where does your eye want to go? Frame it up... make all the adjustments. And right before you take the photo, ask yourself, "Why?" If you're pleased with your answer... take the shot. It belongs to you, but nothing should be casual.

And as long as your moment truly resonates with you... if it causes your mind to drift off to some other place, then something special must be in front of you... and nothing or no one else should matter. We all have lives that are broken up into smaller or larger pieces that make sense to no one else but ourselves.

SENSE OF PSYIGHT

Isn't it absolutely wonderful when we can have a nice conversation about what we see? Our *Sense of Psyight* can bring two people together that have absolutely nothing in common.

Some of the most inspiring moments that I enjoy taking are when I catch someone preparing. Ever seen a bass player warming up? The strings have to be adjusted in order to play in perfect harmony with the rest of the musicians. I can relate. As a trumpet player, I understand the mental prep that this artist has to go through. Its the calm before the storm that must be conquered. The bassist has to hear the notes before hand. He has to make sure that his environment is just right before starting to play.

There is an entire generation of black people not being seen correctly... if at all. What happened to our Psyight on this seemingly ignored segment of the U.S. population? Who is looking at them through which lens to snatch which moment? Is it an honest moment... or is what we see too shameful to bring into focus? The vanishing or nonexistent images of blacks in film and television are tied to an erosion of an already tainted view of themselves that is connected to 439 years of captivity here on U.S. soil. This erosion has been perpetuated over the last century by any and every black man who has chosen to coon and buffoon on screen in front of millions. One moment... stacked upon another... until a thick concrete has been poured over the strongest rebars of tension-filled stereotypes.

And the black woman who laughs at these emasculated black images does so because it makes her feel better about all the burdens that she has been forced to carry. She is really laughing to keep herself from crying. These images help her to completely surrender to the notion that "We will never make it unless I show up to save the day." But who will show up for her? Who will she allow to show up for her?

What happens when the single black mother comes home and discovers that the unique maternal love for her surrogate husband has expired because he's going off to college... or better yet... getting married? How will this next generation black man view the next generation of black women? Will the Queen want a King... or just a Prince? I worry a little for their *Psyight*.

At work, what happens when a black woman's boss devalues (hates on) her innovative ideas? It seems like that boss has made it her job to make the woman's career stagnant and unpleasant. She gets busy trying hard to be all things to all people. She then instinctively turns that frustration of marginalized power back towards her entrepreneurial black male counterpart (who has become well adept at forging his own isolated path). When she's had enough, her *Psyight* will allow her to see a better path of happiness that she and her man can share. The world is theirs if she can ever learn to just let go.

I grew up 45 minutes off the shores of Jamestown, Virginia. The sinful moments of this country's forefathers are so shameful that some attempt to distort the impact of slavery in history books for our fourth graders today. I know this to be true because my little nephew Justin is one of many VA fourth graders whose *Psyight* is being eclipsed. It is important that he and other children learn how to celebrate the uniqueness of their own heritage without feeling ashamed. Our *Psyight* is the "Outstanding Teacher" of the year... every year.

Apologies can be neither forced nor expected. All we have is the moment that stands before us. And if this is the case, I want every single one of my moments to count. We have to continue to allow life to unfold... regardless of wrong doings. Our *Sense of Psyight* is here to keep us honest and maybe offer us just a little bit of atonement.

An Artist

has to keep his/her *Sense of Psyight* razor sharp. So that when the right opportunity presents itself to direct, paint, write, act, sculpt, produce, or play music, you will have acquired or maintained the necessary confidence and acumen to pick and choose what truly moves you. This is neither arrogant nor rebellious. The might of your Psyight is absolute and pure. She will come at a high price. It will cost you time, sleep, and possibly a few friends. But I believe the benefits will outweigh her many costs. The maturity of this unique gift will keep your eyes from being overly critical and judgmental... but empathizing as to how an object arrived in its current state of being. With that said, to deny your Psyight altogether is to deny one of your many gifts from God. And when you tell God "no", He simply gives your unused portion to someone else. Those who are contemplating how to embrace their Psyight may think that the sacrifice towards their creative genius is too great, but it actually moves you closer towards your true place of purpose. I strive to be in a place where God is happy with what I am doing with His gifts.

Your "Sense of Psyight" is simply empowering oneself to create from a place of inner peace, strength, and inspiration... vs. fear, desperation, obligation, or even manipulation. It is your God given ability to sort out the ambiguous still moments of your life's journey. And since you're the one doing all of the walking, why not show everyone what you truly see?

TWO UP/TWO DOWN (VA)
BIRTH & DOOR

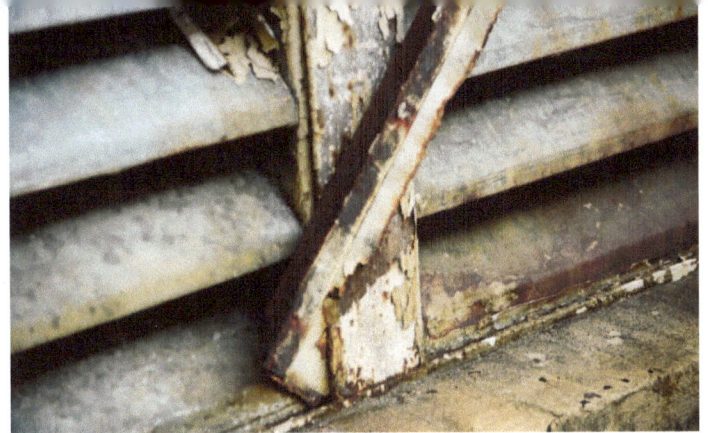

Series: DELIVERY -- My place of birth... on my most recent birthday. Quiet. Surrounded by life. The first. Tried and strong.

Series: LONG TERM MEMORY -- On my most recent birthday and a few minutes from my place of birth, I decided to take a trip to the first neighborhood that I could remember. The door represents the portal of my memories til age 6. The door to leave for my first day of school. I ate a bowl of Trix Cereal for breakfast. I wore a pair of baby blue "Chuck Taylors"; The same door where I locked my Aunt Cookie out when she made some horrible tart cookies; The same door where I would run to tell my father that the boy in the adjacent beige house (below) had accidentally hung himself in a tree; The same door that I would use to take my brand new purple bike in and out of the apartment building. I left that door because Dad wanted another.

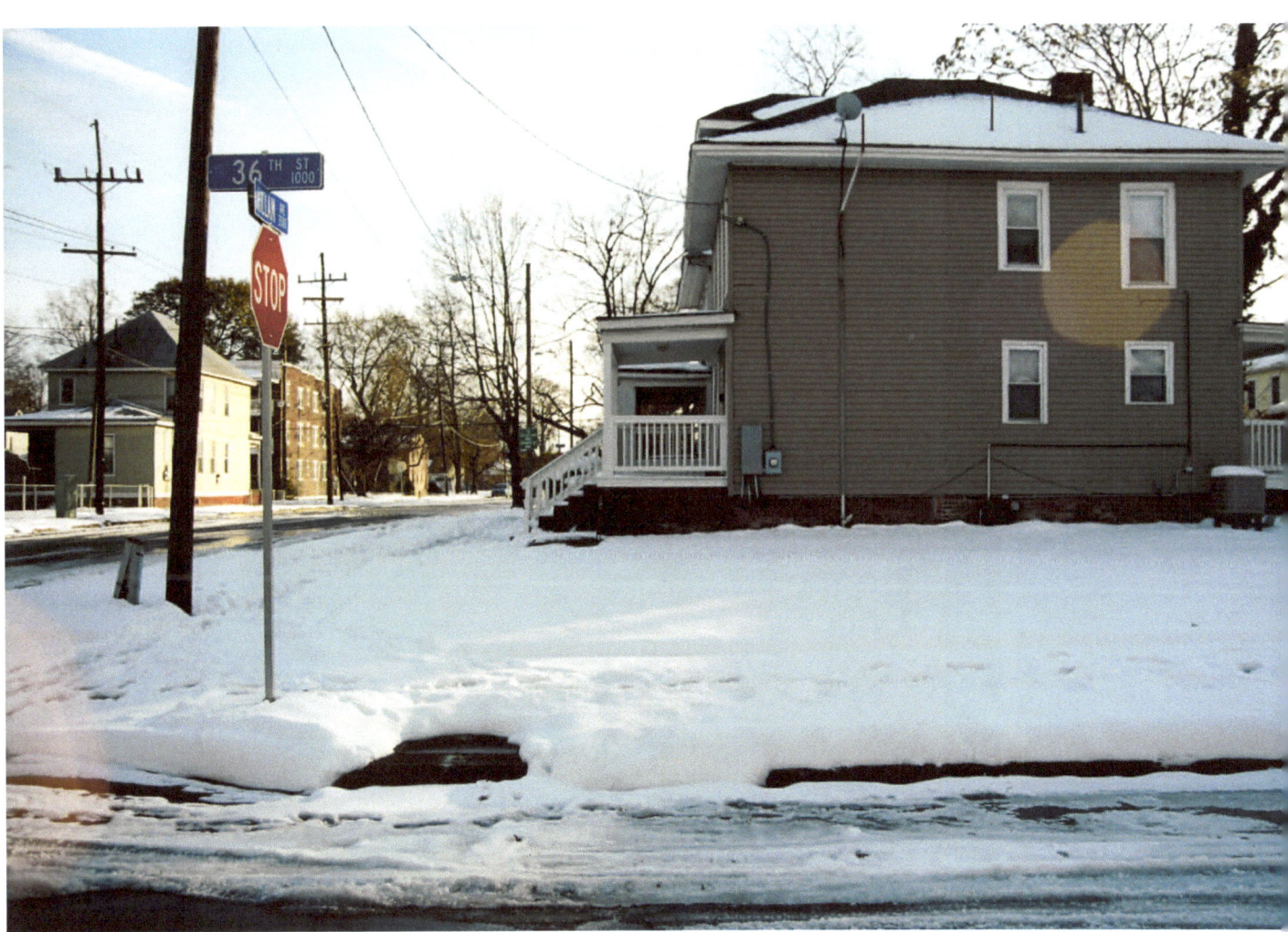

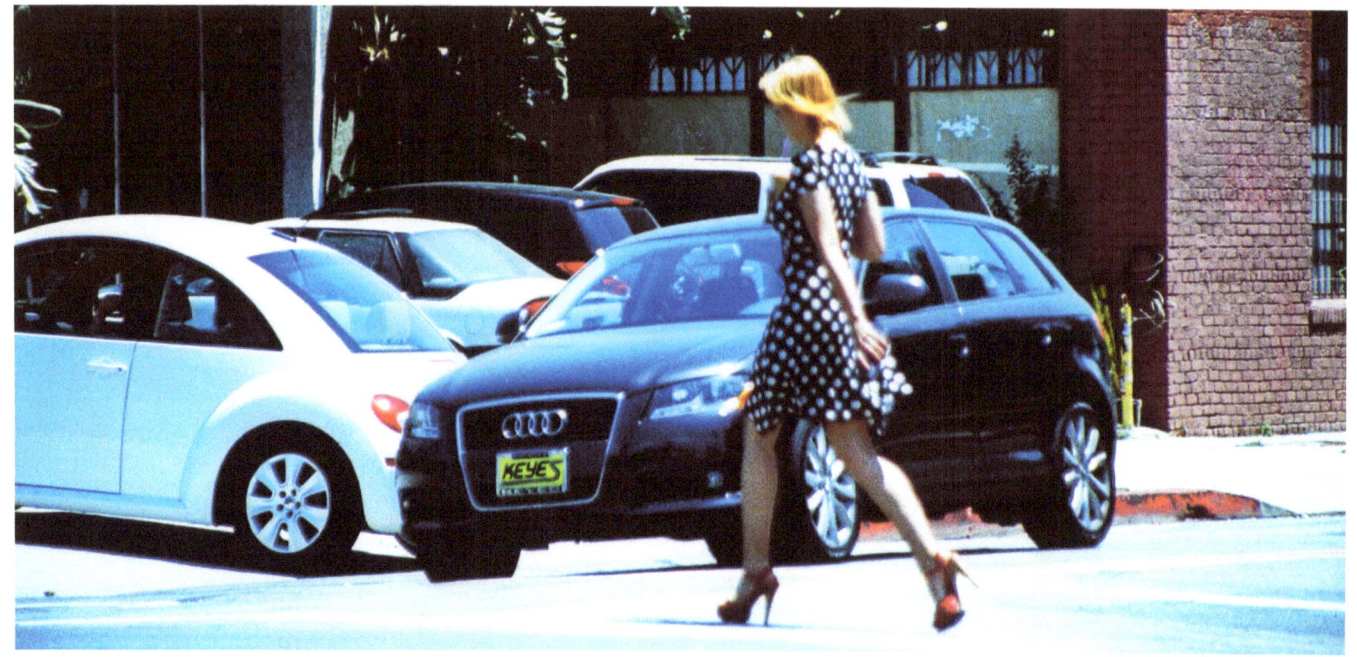

MELROSE & MID WILSHIRE

Series: POKED -- I was sitting across the street at a burger joint, and this sexy woman and her snazzy dress and heels comes into view. She only has 10 seconds to get across the street before the light changes.

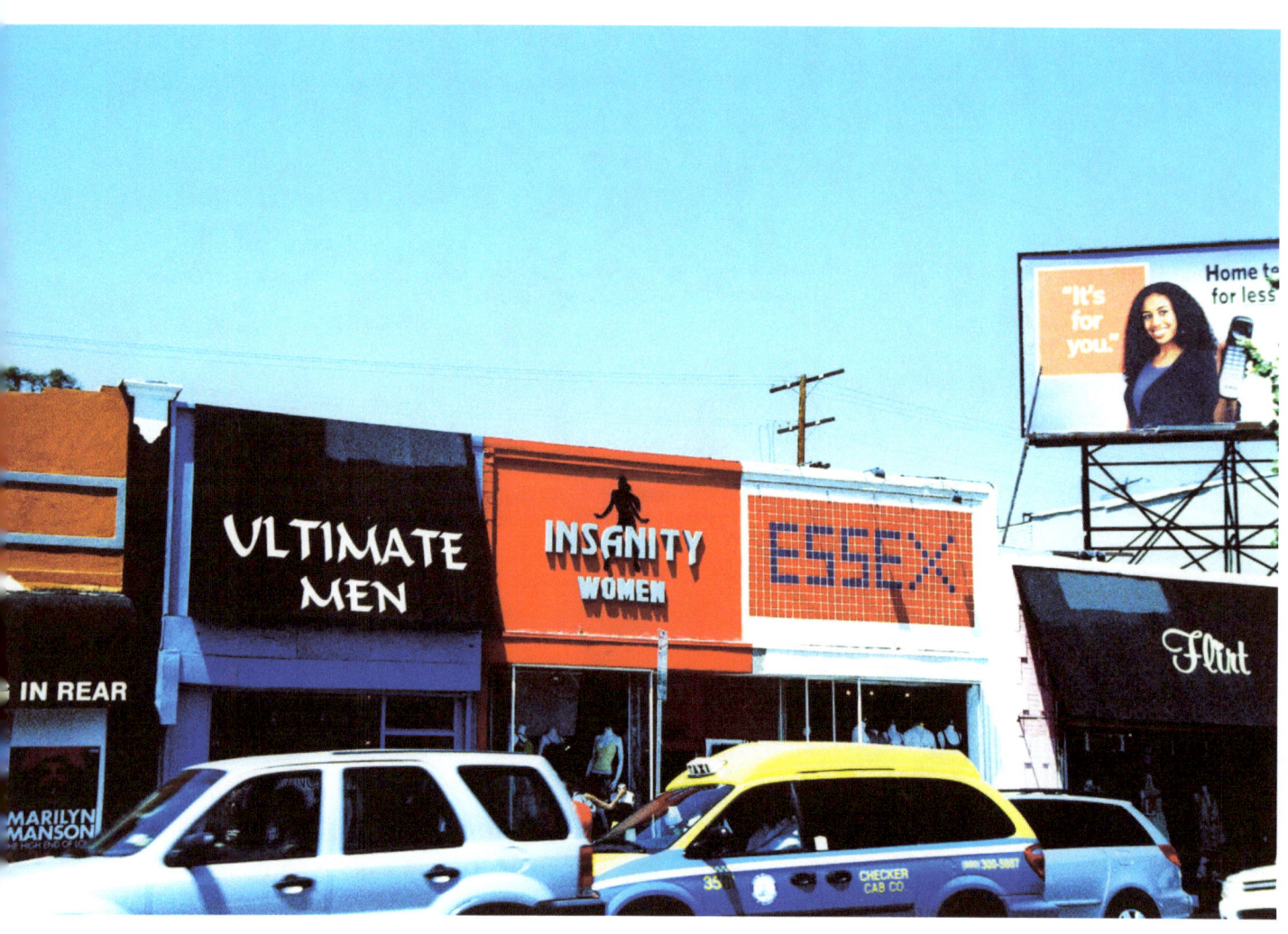

Above: ONE MIND

Top Right: GLAM SQUAD

Bottom Right: PACKAGE STO'

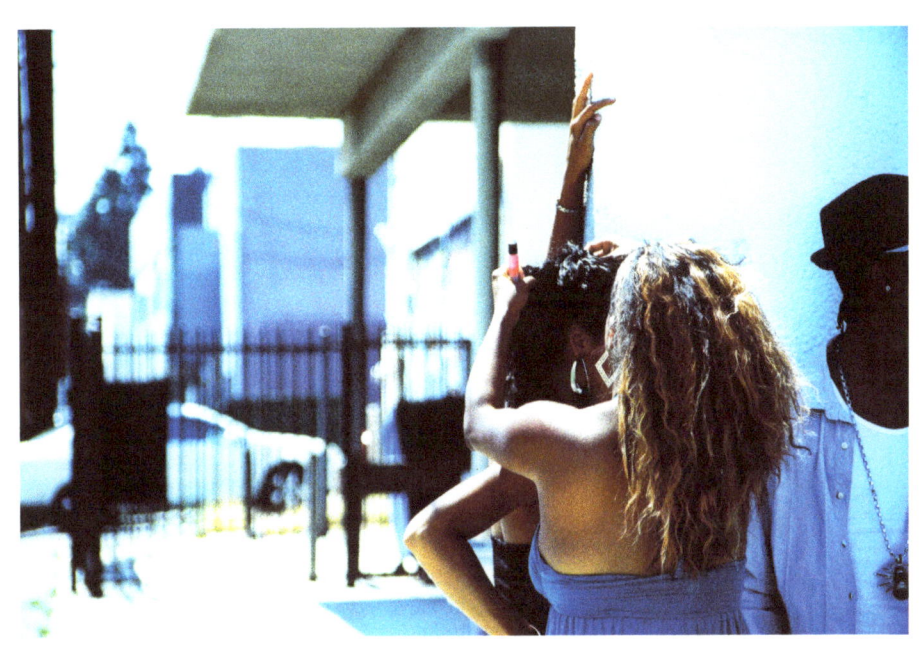

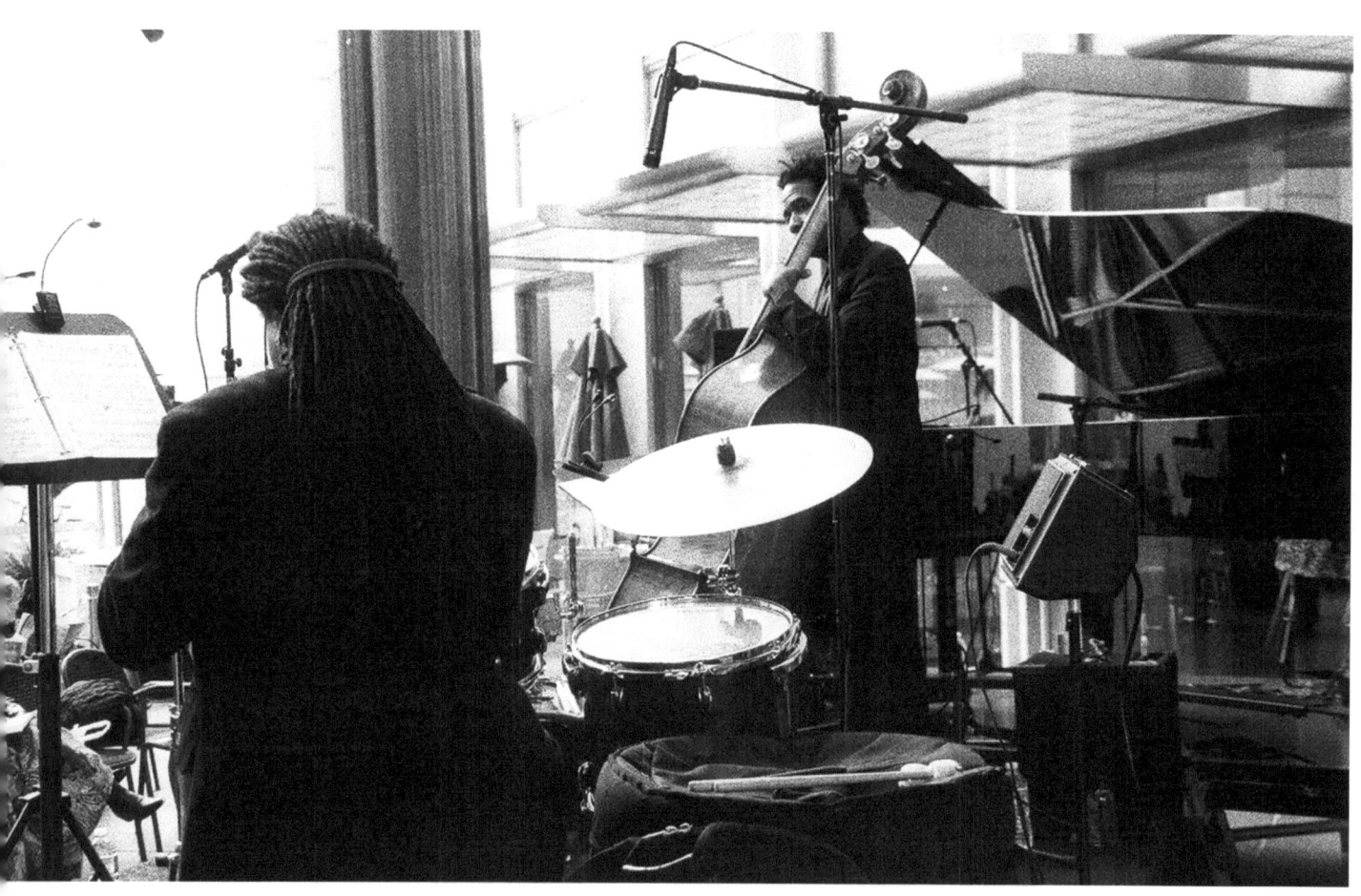

Above: EVERY FRIDAY. -- Warming up is a performance in and of its self. Its special. Zoned out already.

Overleaf: CENTER STAGE -- He knows that he's on display.

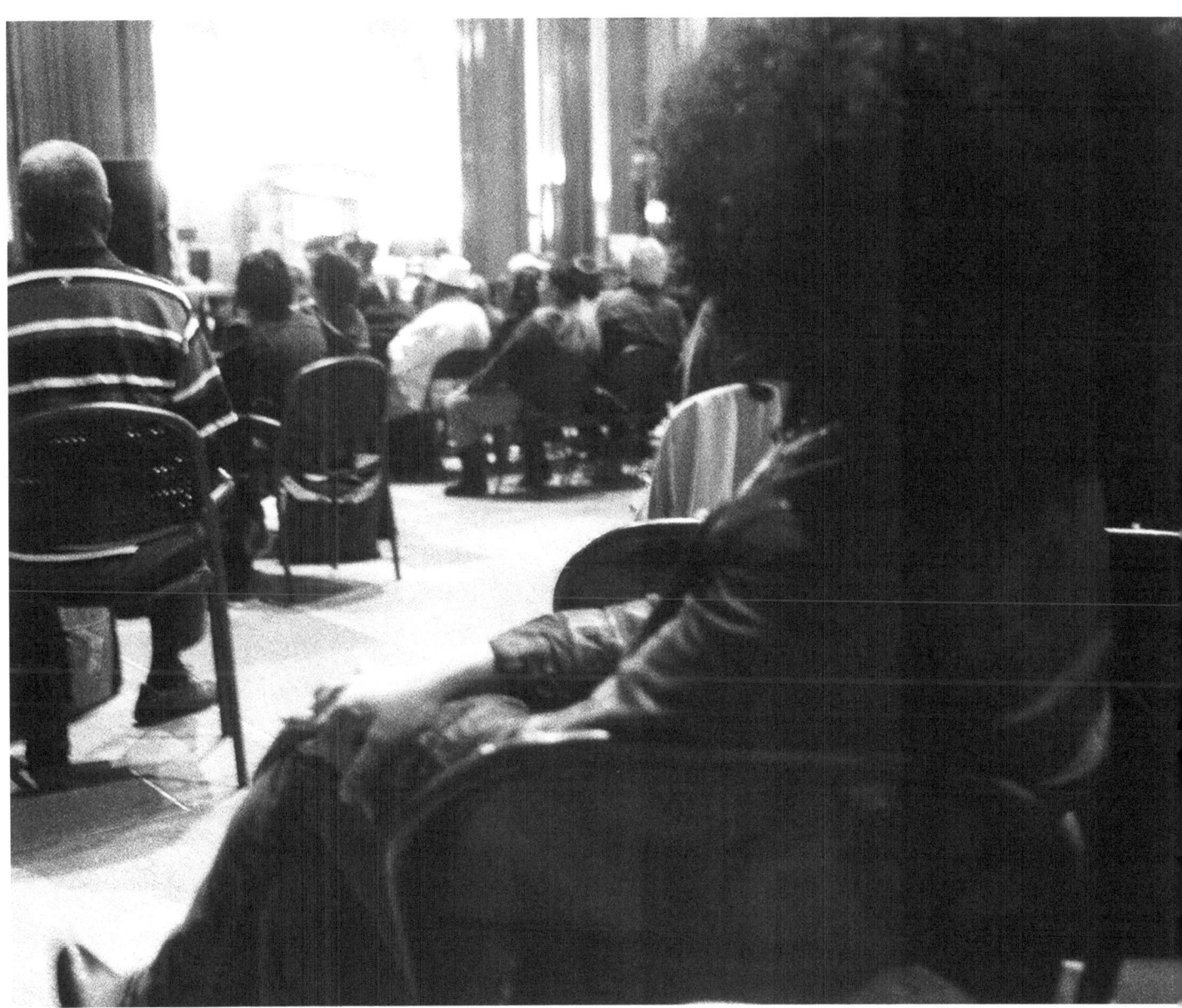

Above: WE HUGGED -- She was so poised. We conversed between songs. She was beautiful. She allowed me to walk her to her car. We hugged.

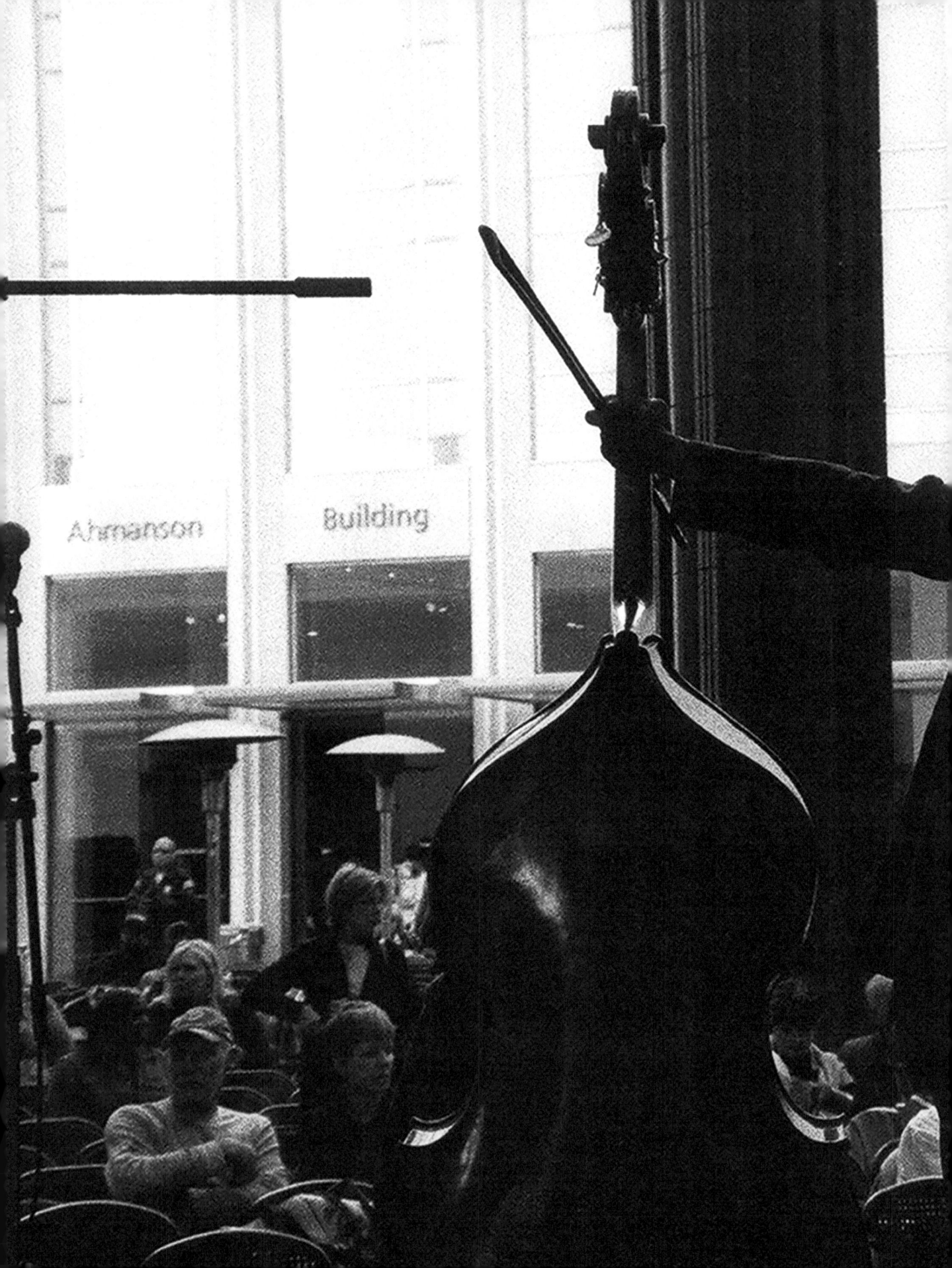

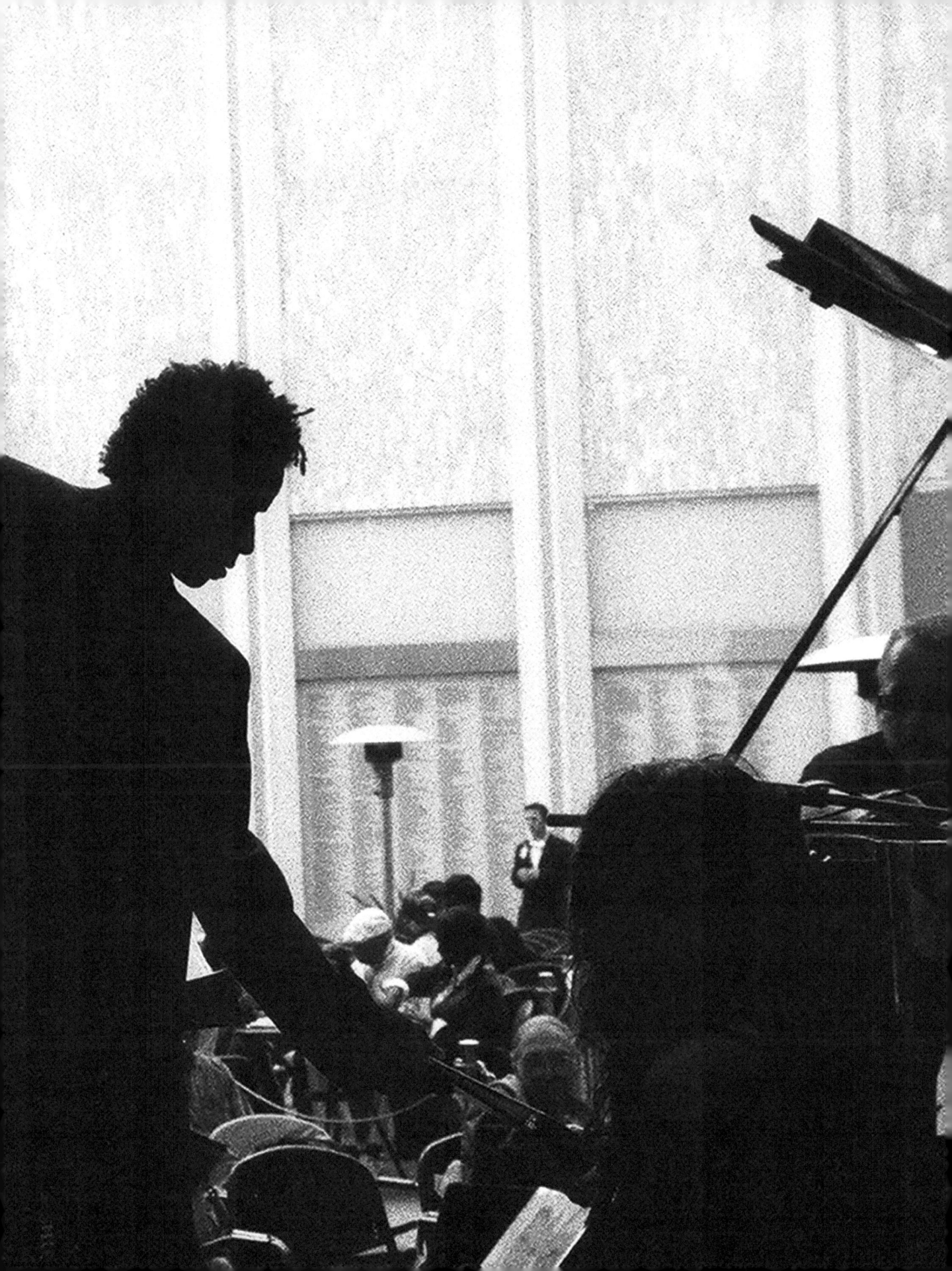

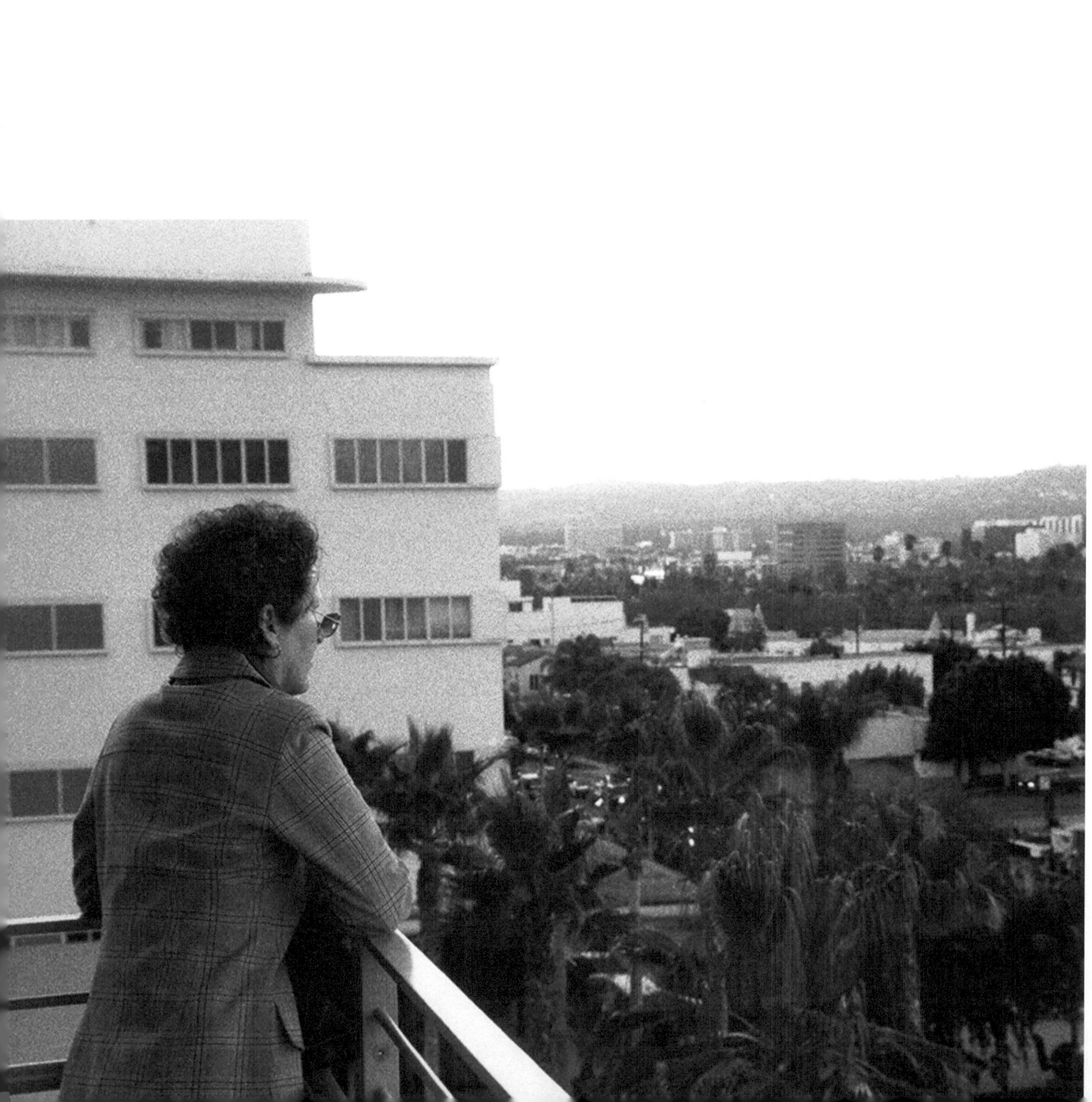

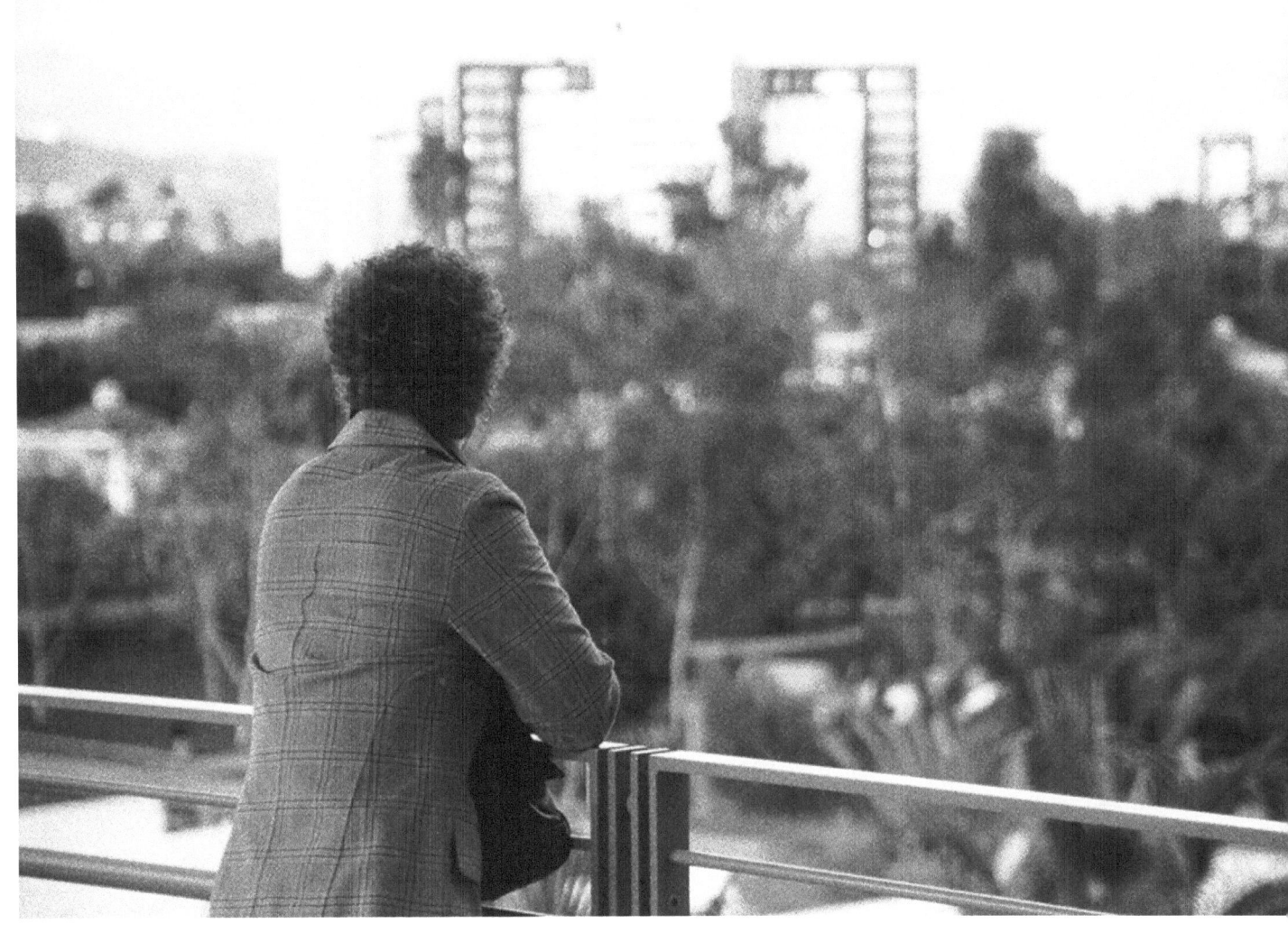

Above, Left: LIVE WITH IT -- The toll... ridicule... the choices. Time heals.

Overleaf: BACKSIDE -- of Downtown LA.

LOOK DOWN + SKID LA

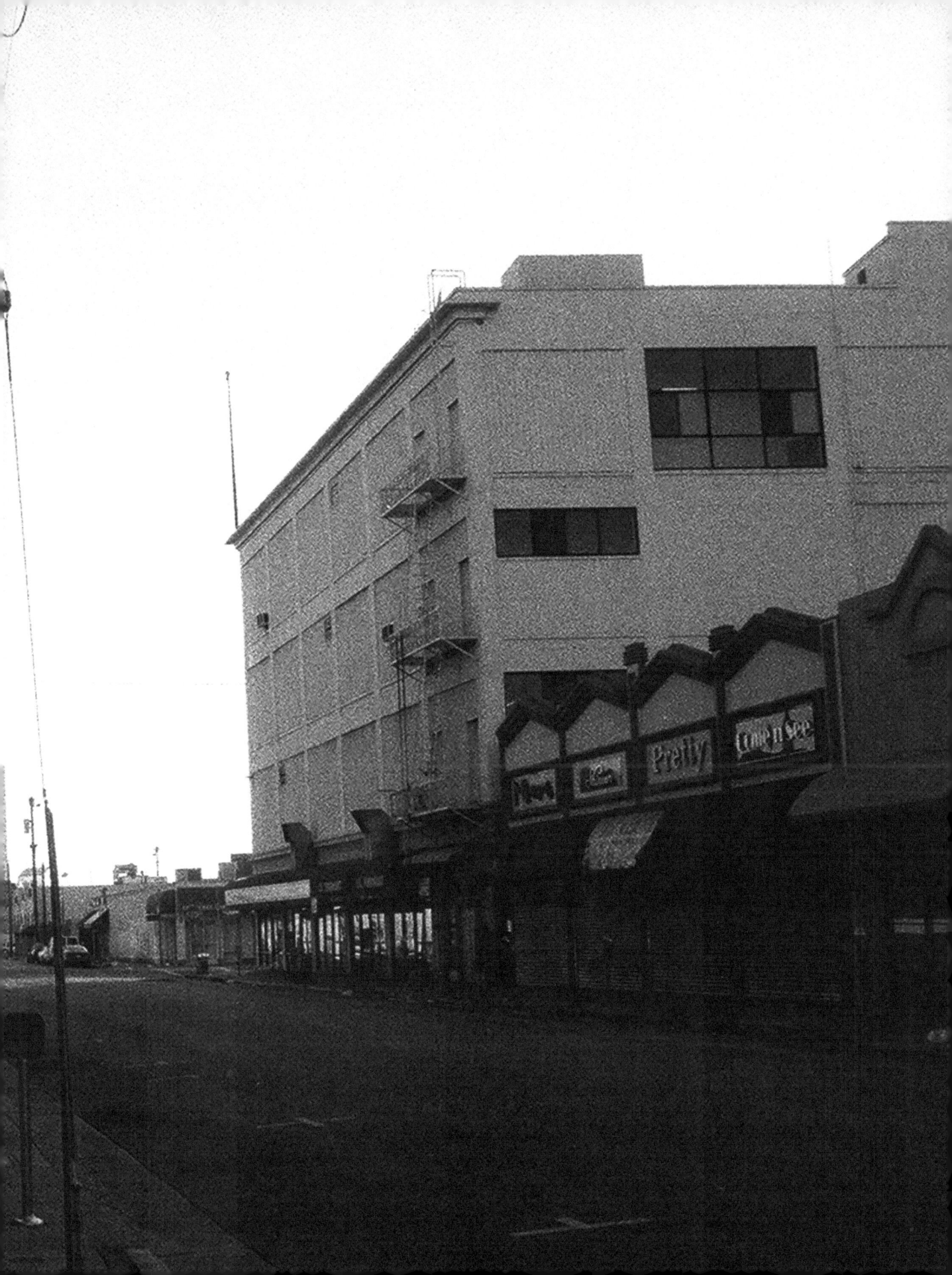

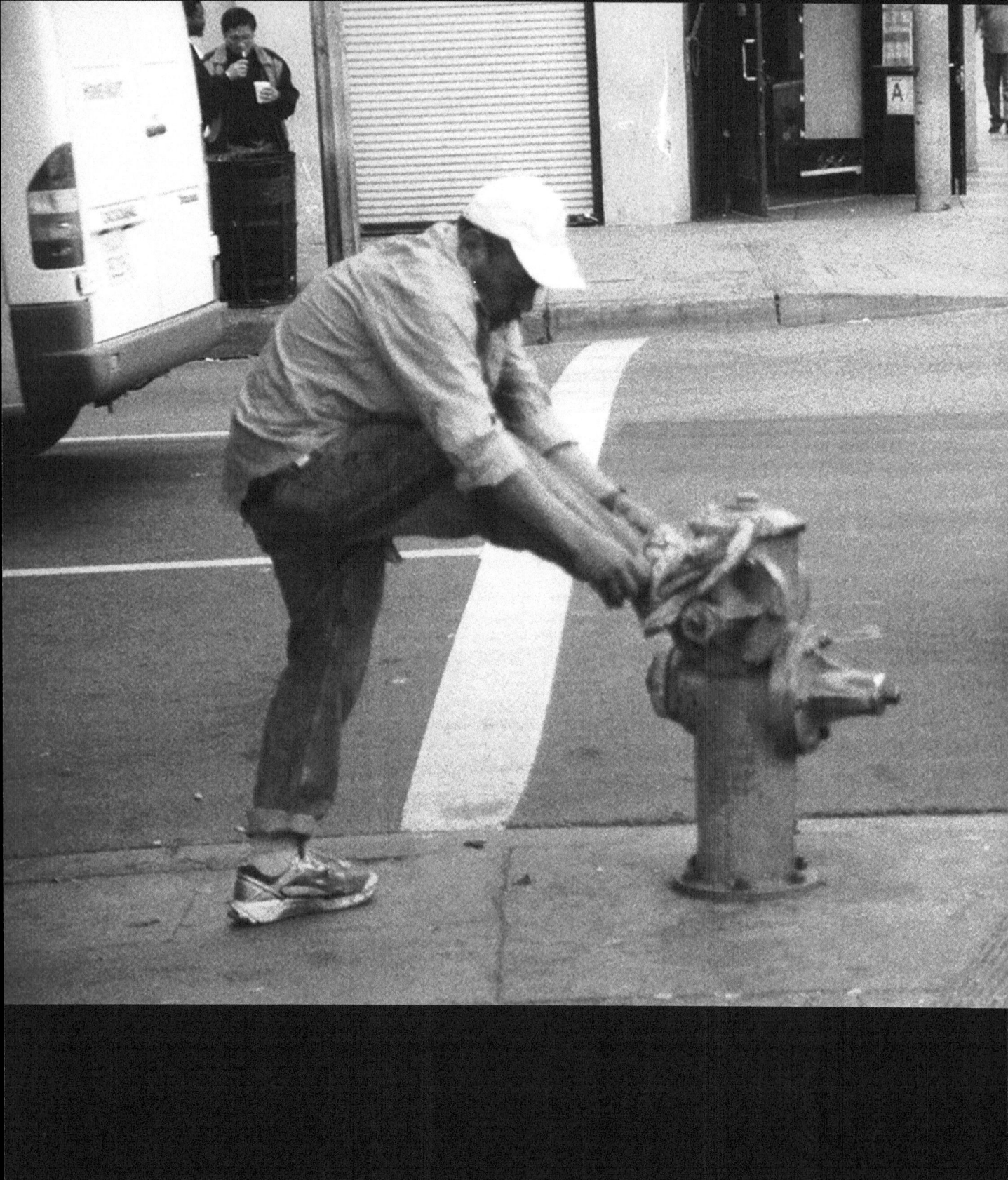

Left: NEAT -- He can still hear his grandfather telling him to tie his shoes.

Overleaf: WATCHFUL -- He can now sleep better knowing that his mother is alive.

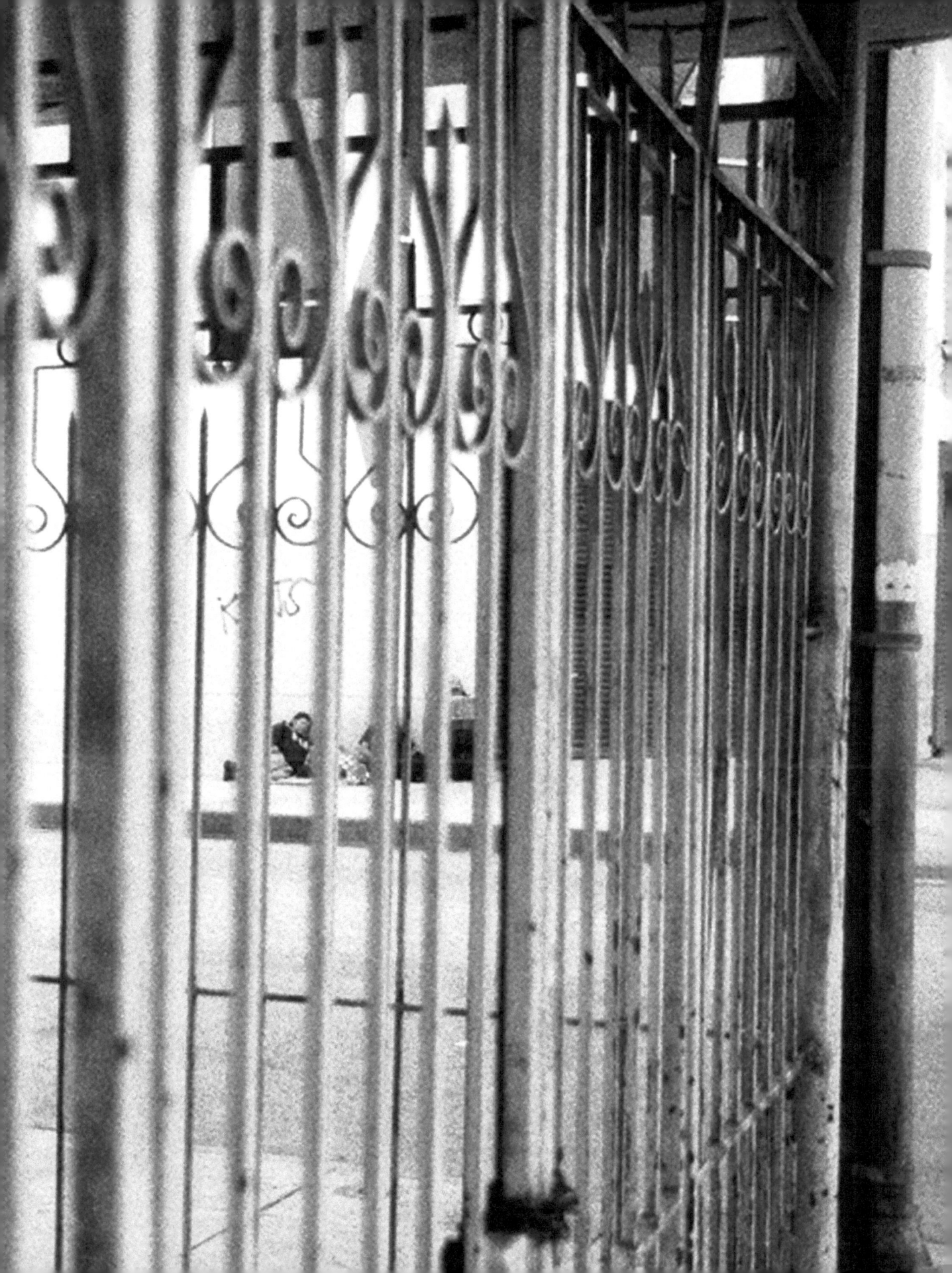

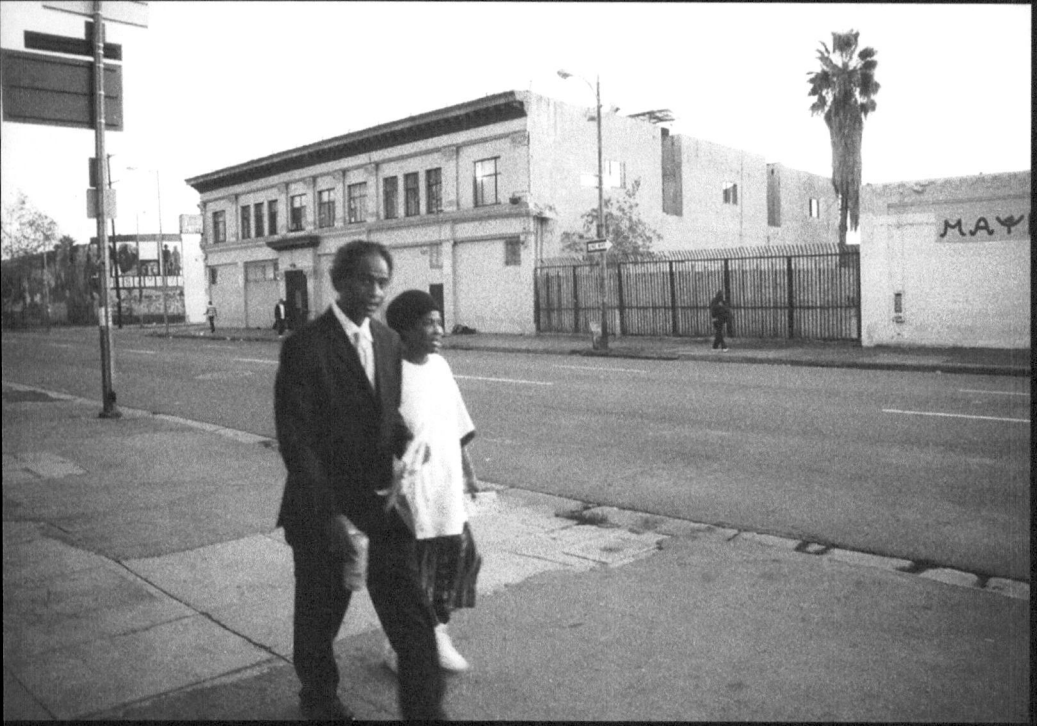

Above: SKIDUCATION -- Just learn as you go.

Left: THANKFUL -- Living only one moment at a time. One second is a work of art.

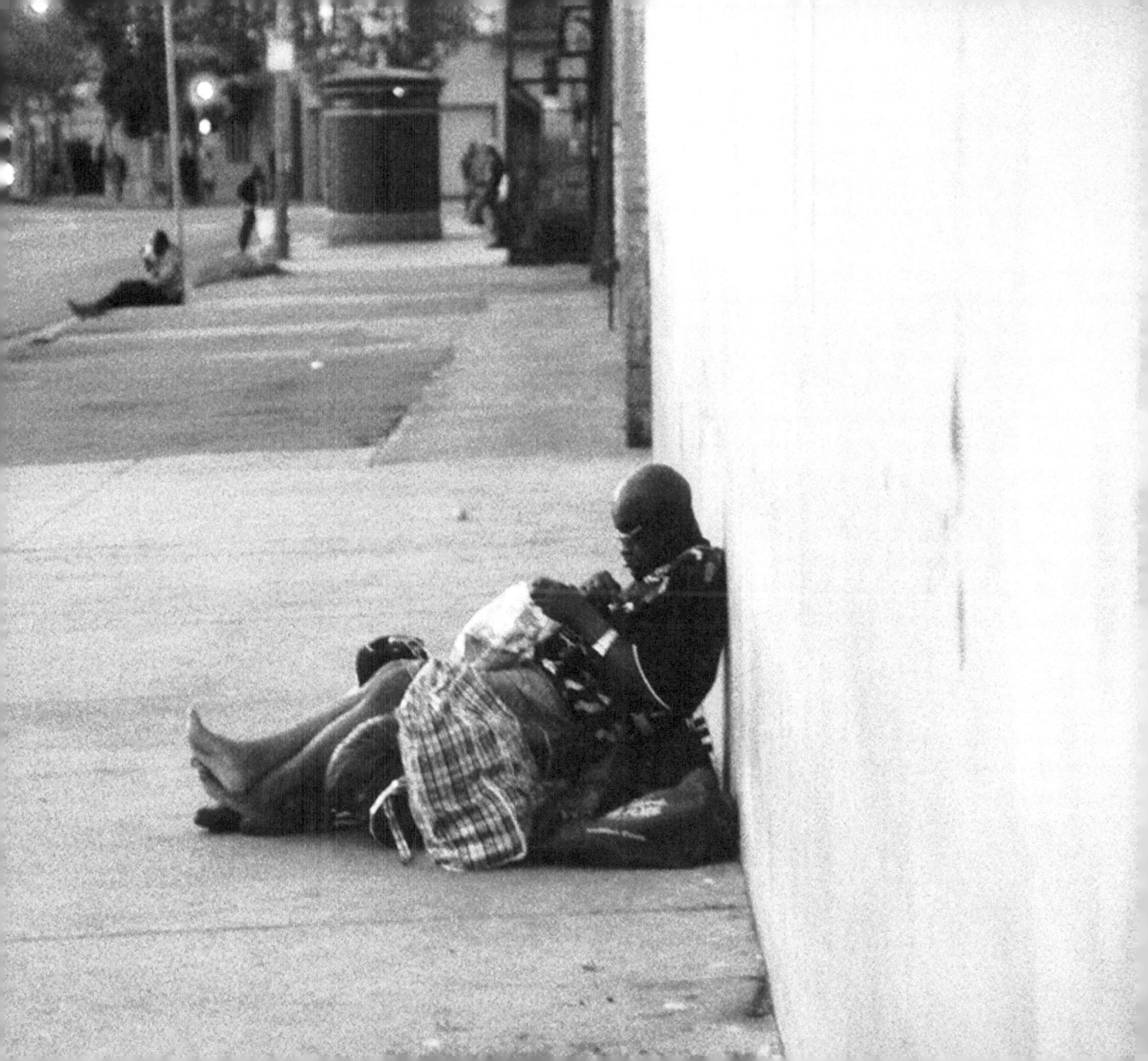

Below: FIRST IMPRESSIONS

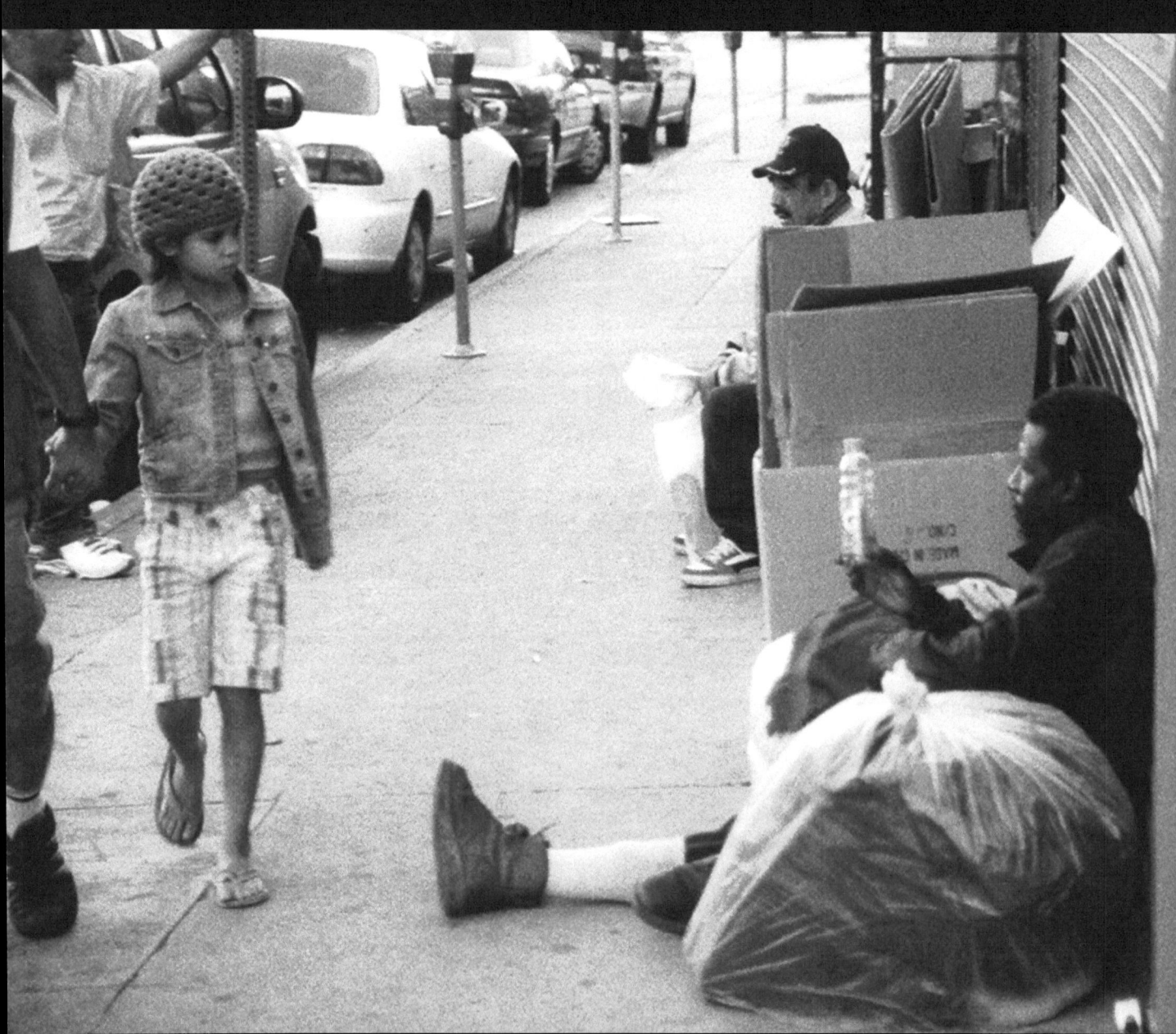

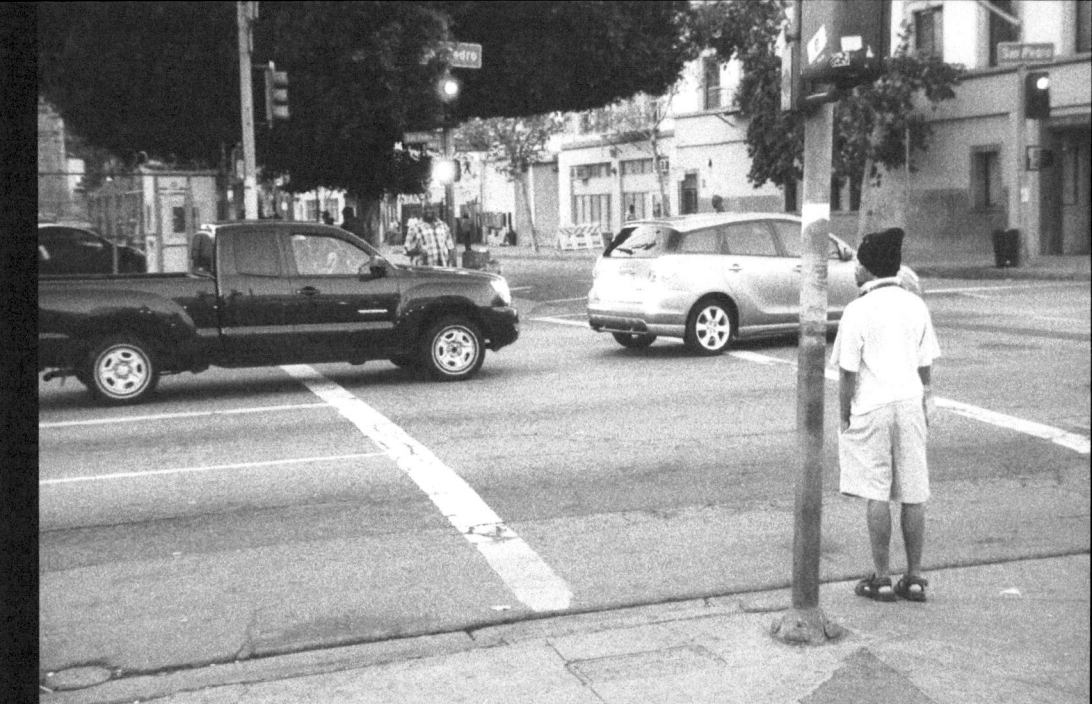

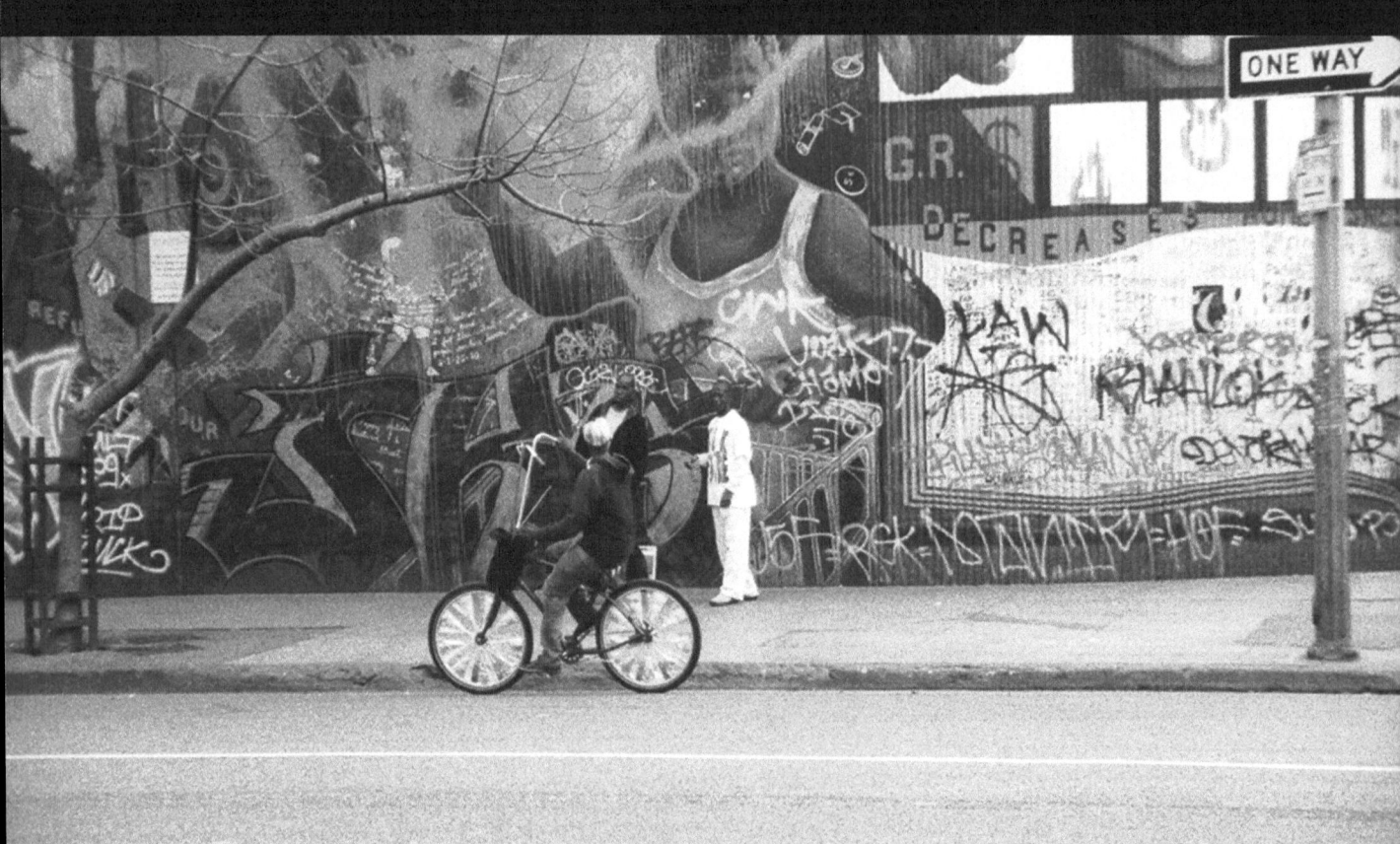

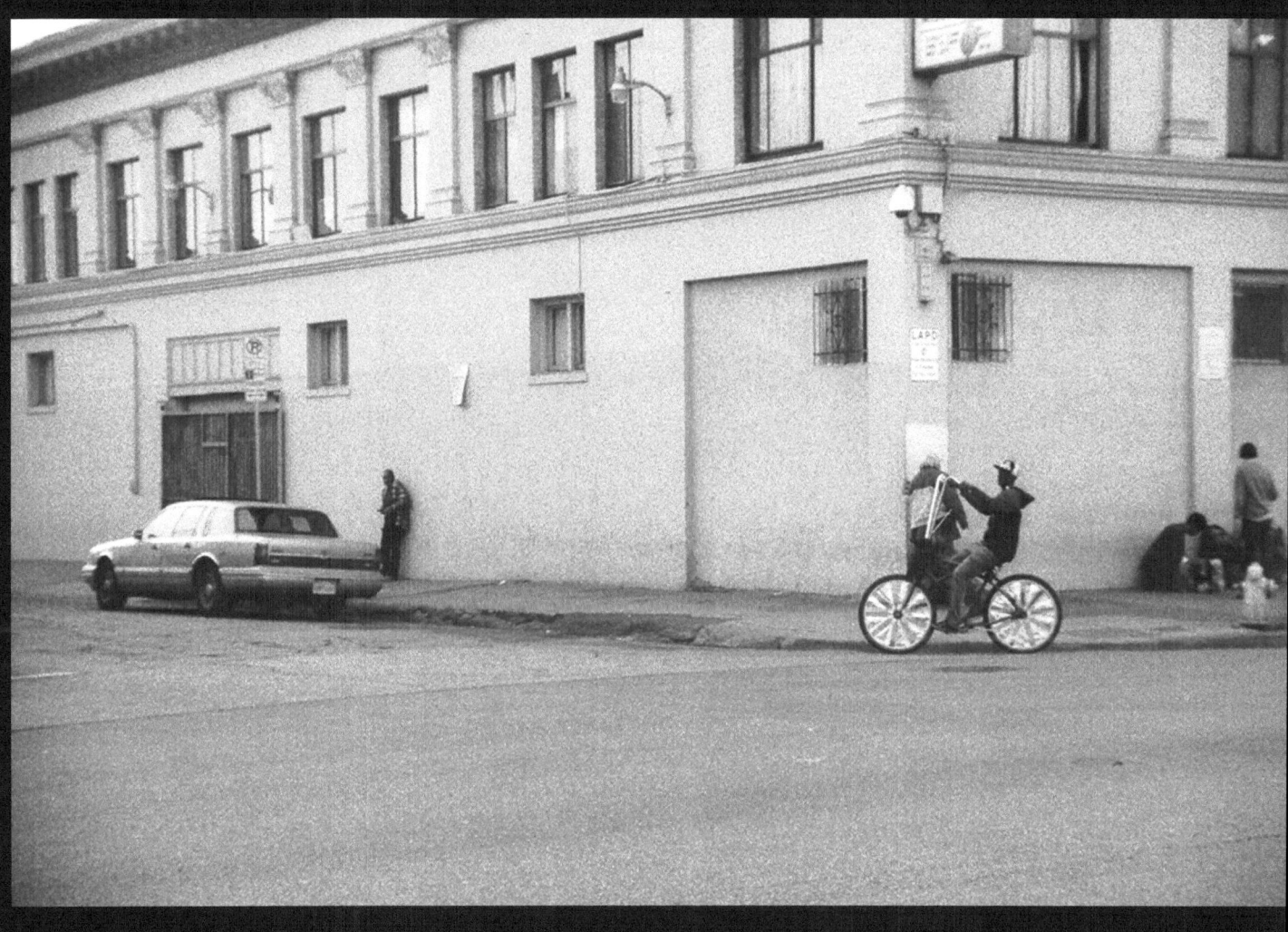

Series SITTIN' PRETTY -- Why obey the law when no one cares?

Right: HIDDEN PIGEON -- Refusing to move.

Left: GONE -- Went away. Maybe they'll be back again.

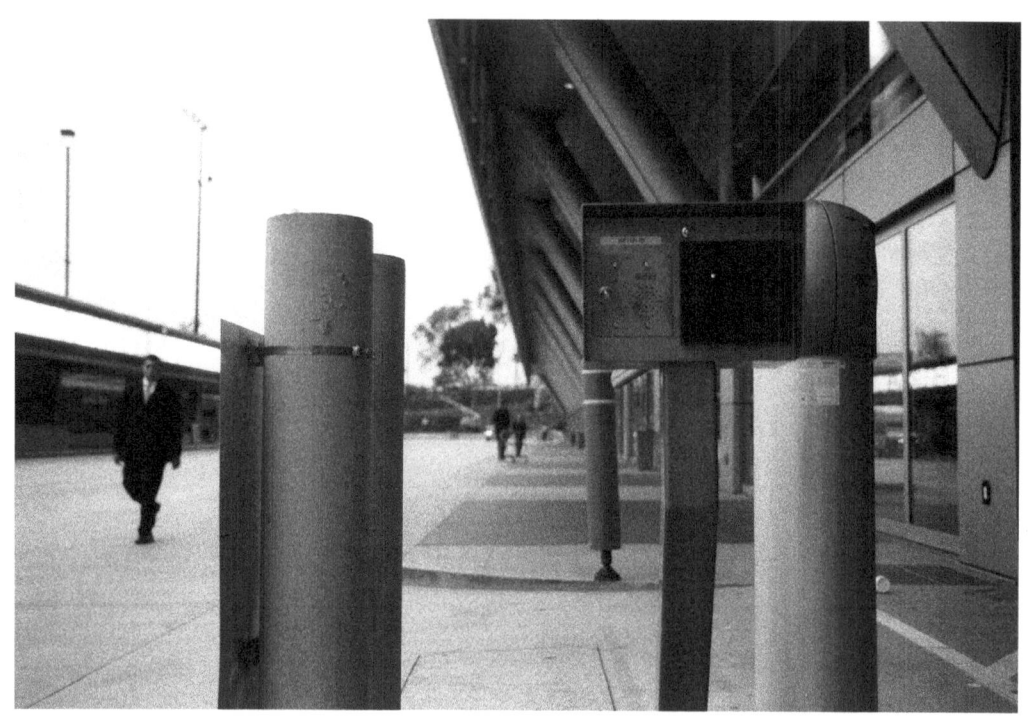

Above: ACCESS -- The haves and the have nots.

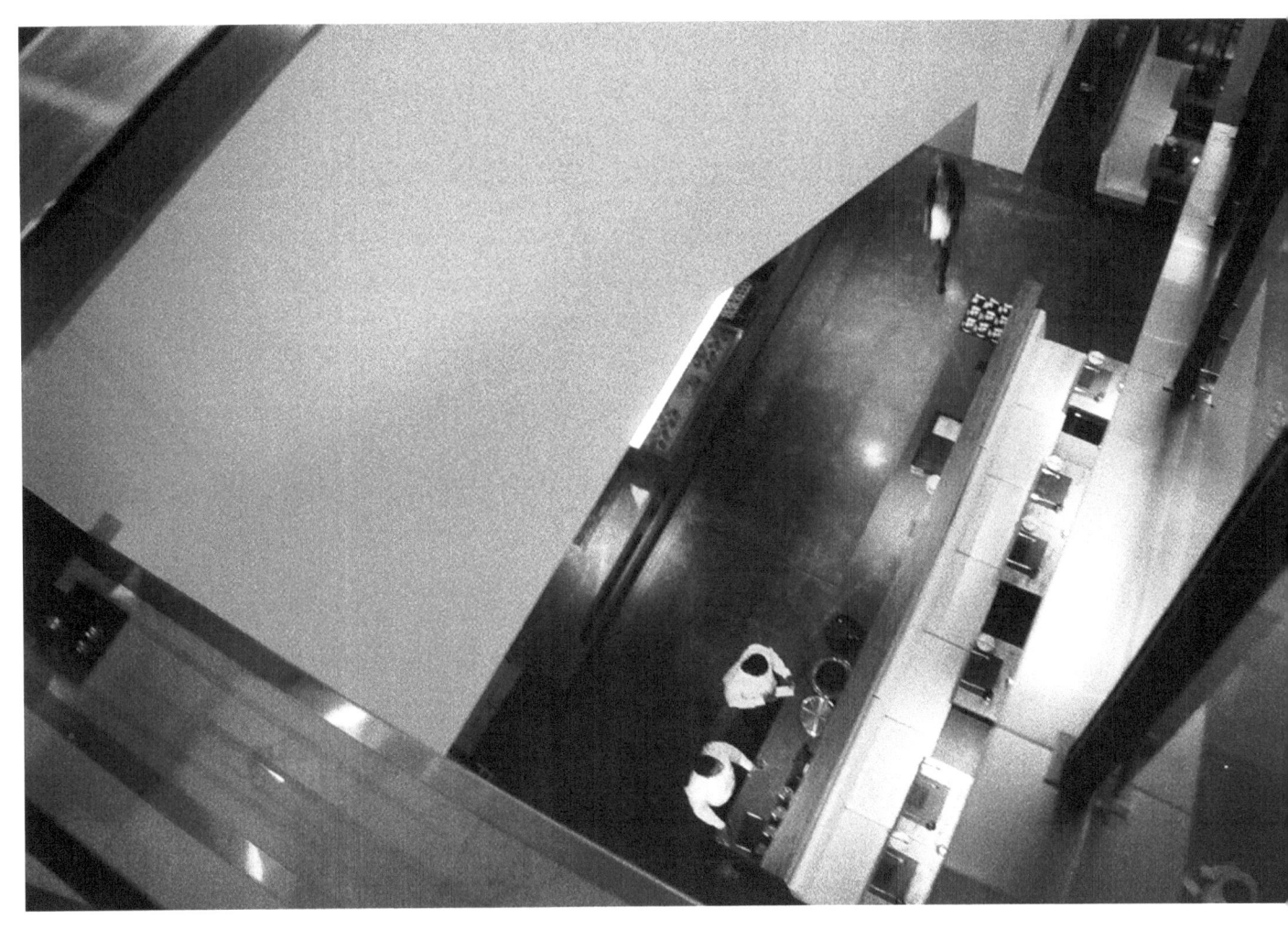

Above: PLAIN PSYIGHT -- Doing just enough in order to stick around.

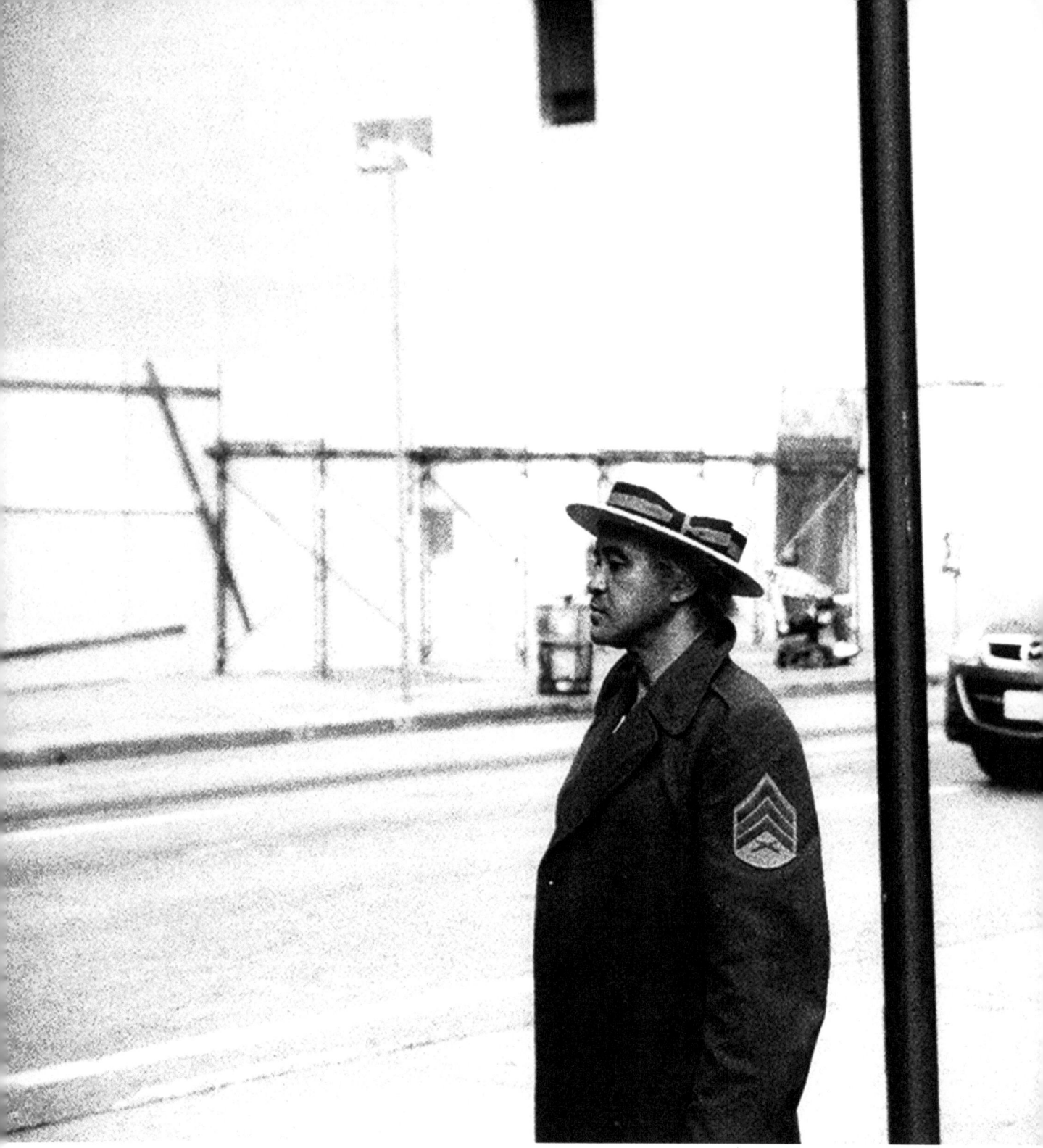

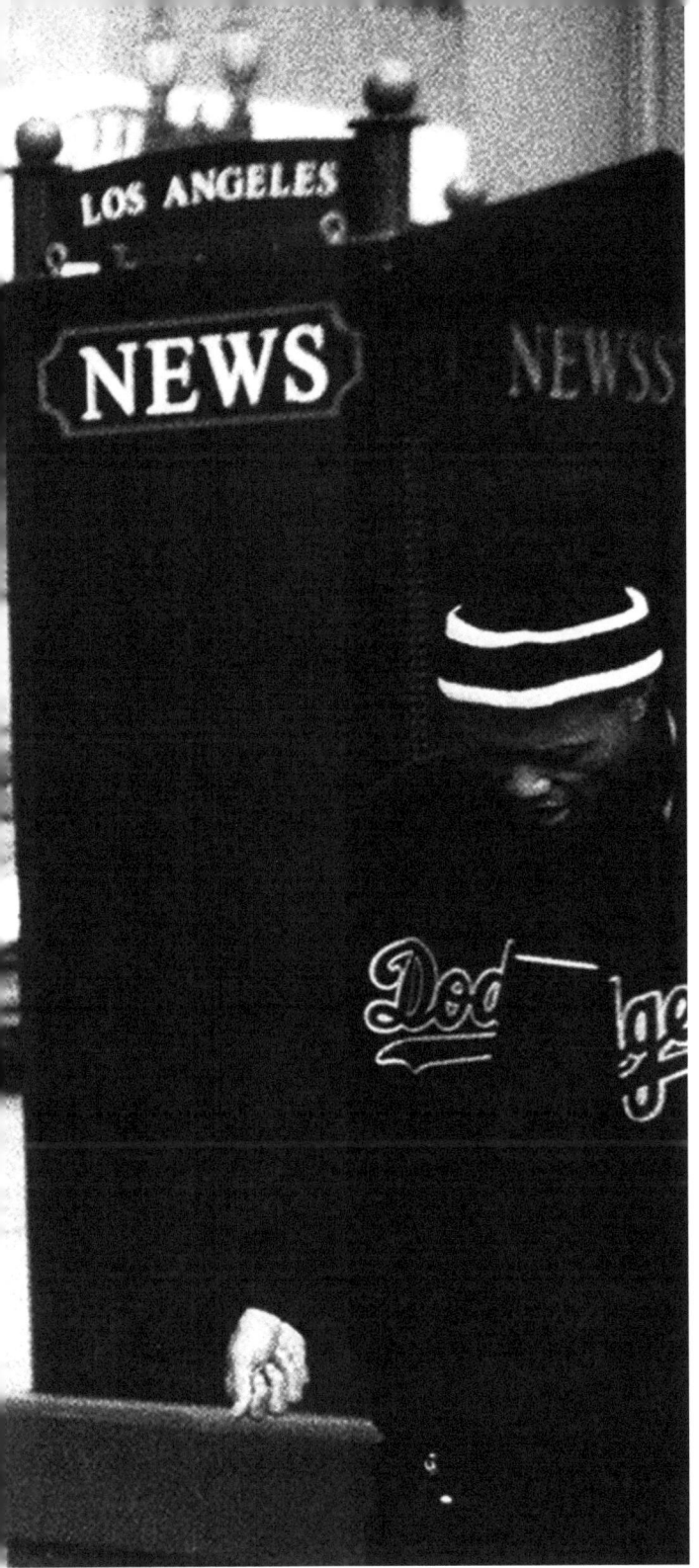

PULLIN' RANK -- Reclaiming takes time.

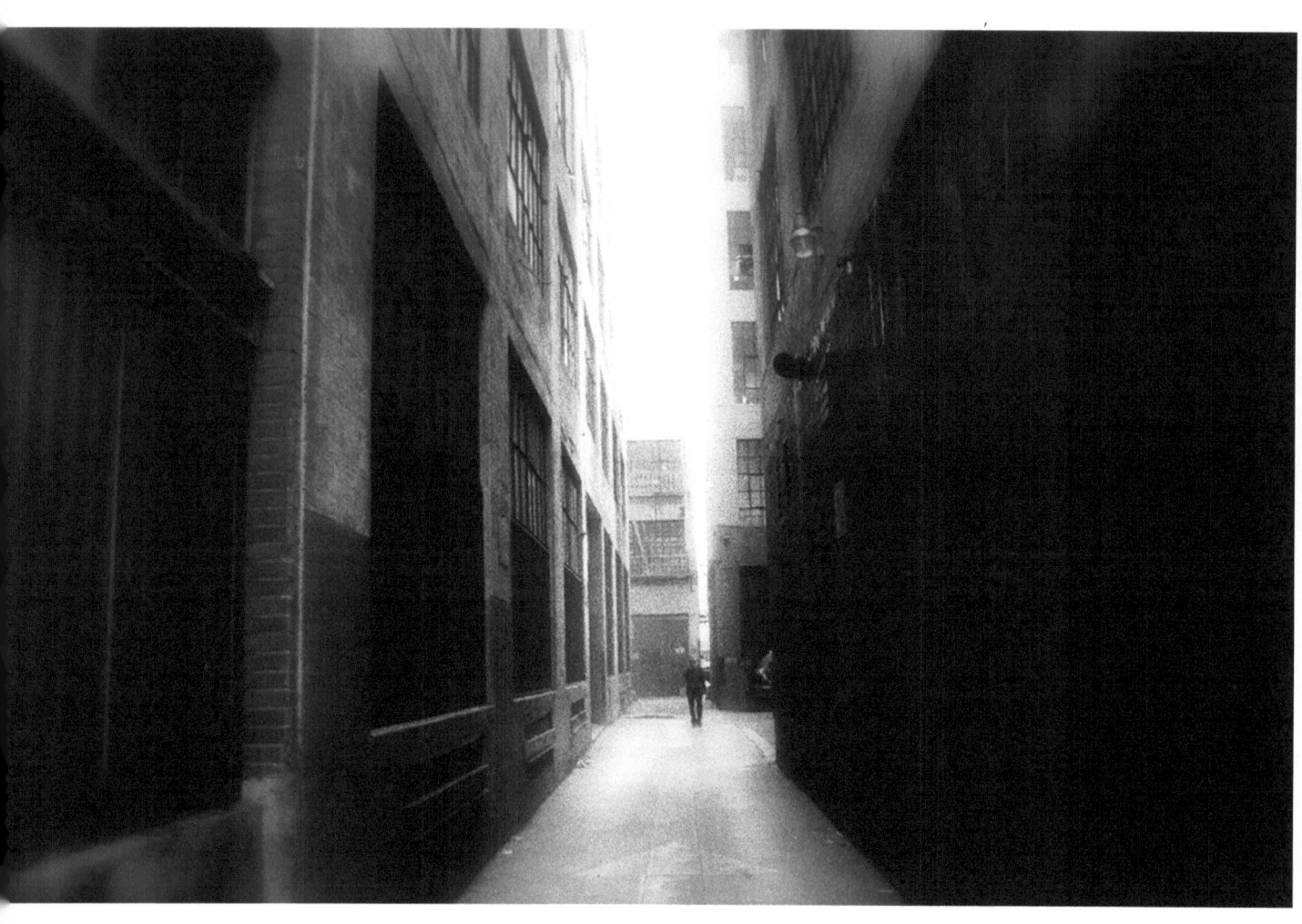

Above: DISTANCE -- Whatever you did, its okay. We love you anyway.

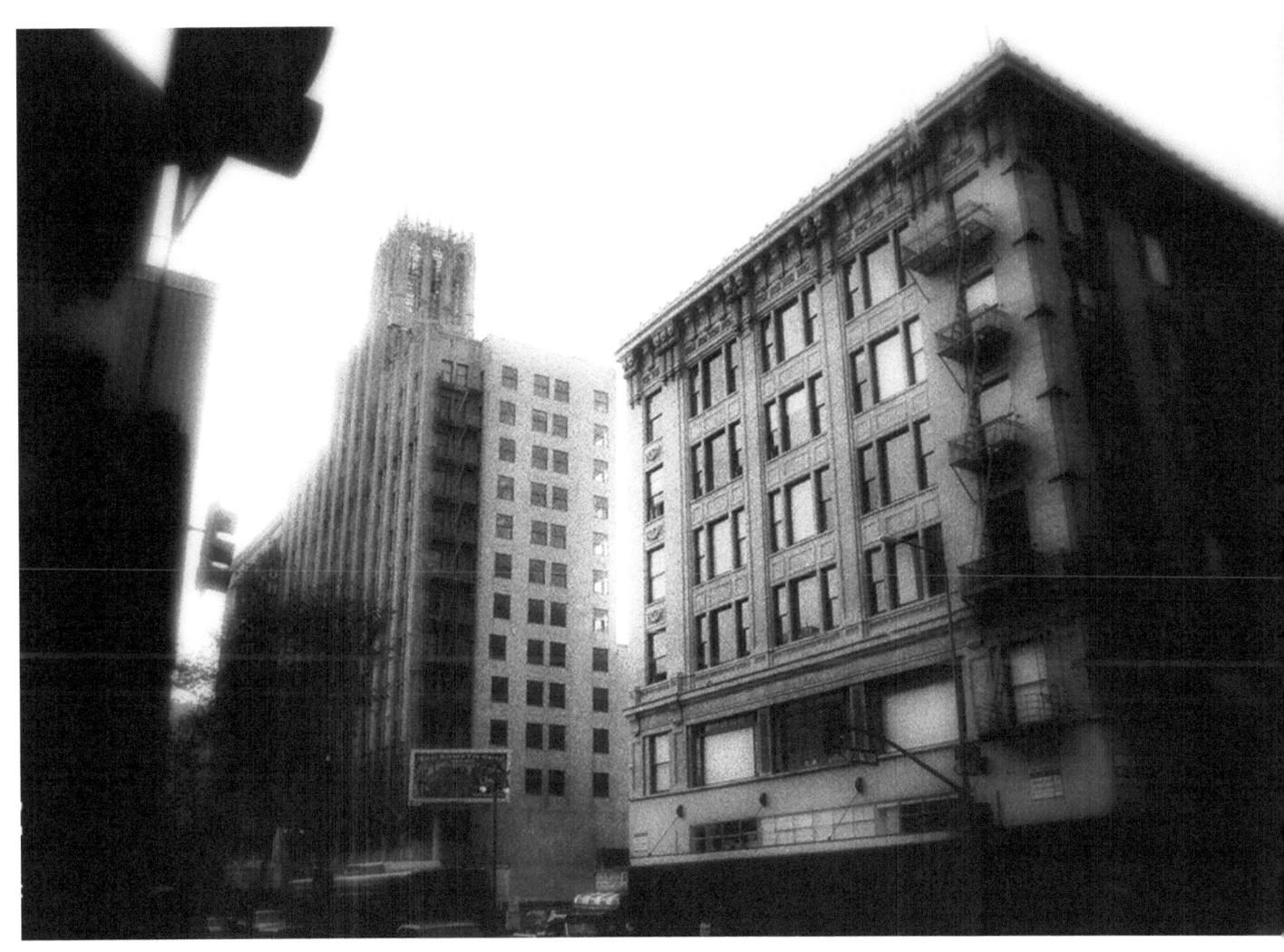

Above: 1st & LAST -- No lease required for happiness. We'll just do a month to month.

Right: MORE OFTEN -- Check out.

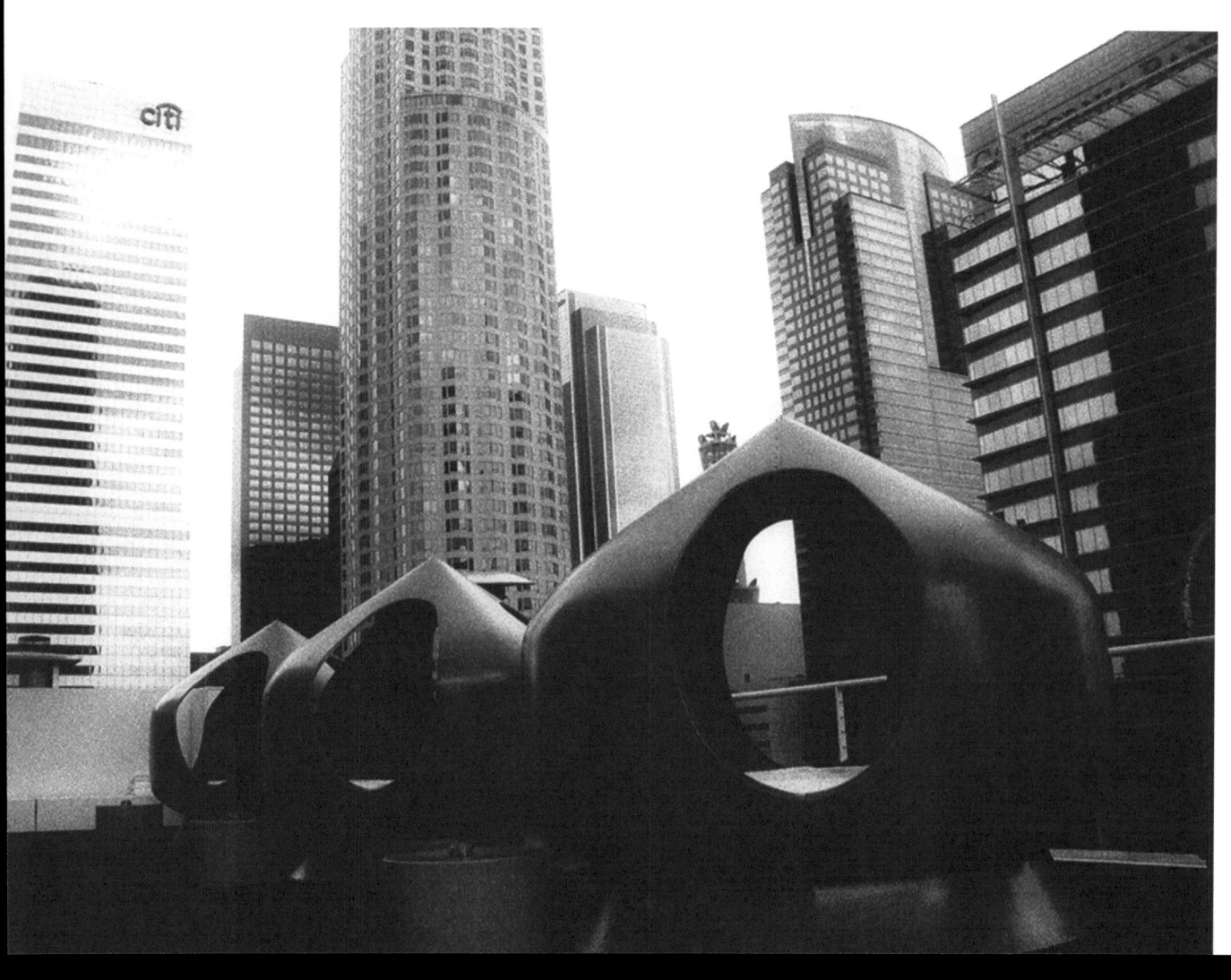

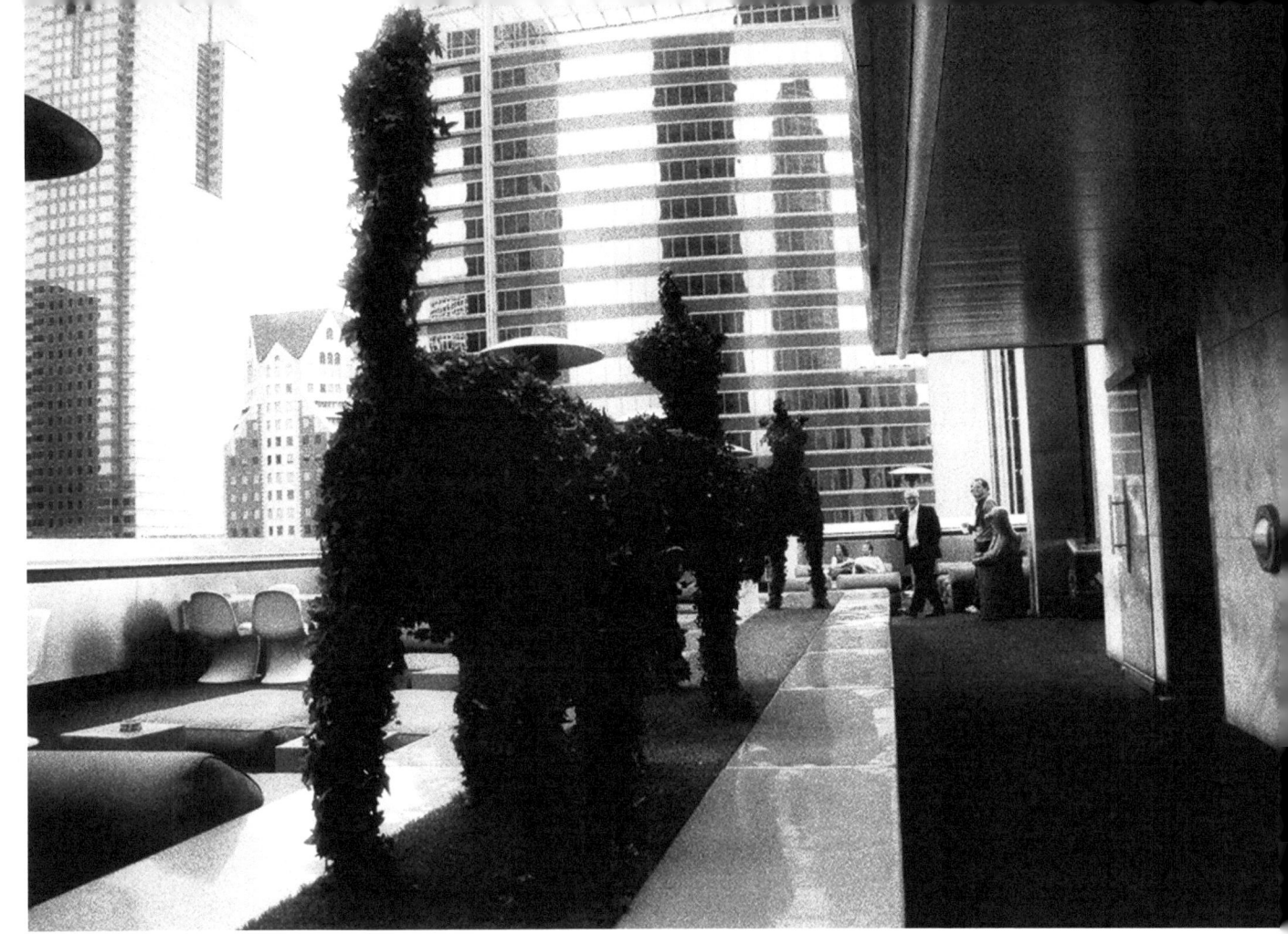

Left: TRUST -- I said, "Let Go."

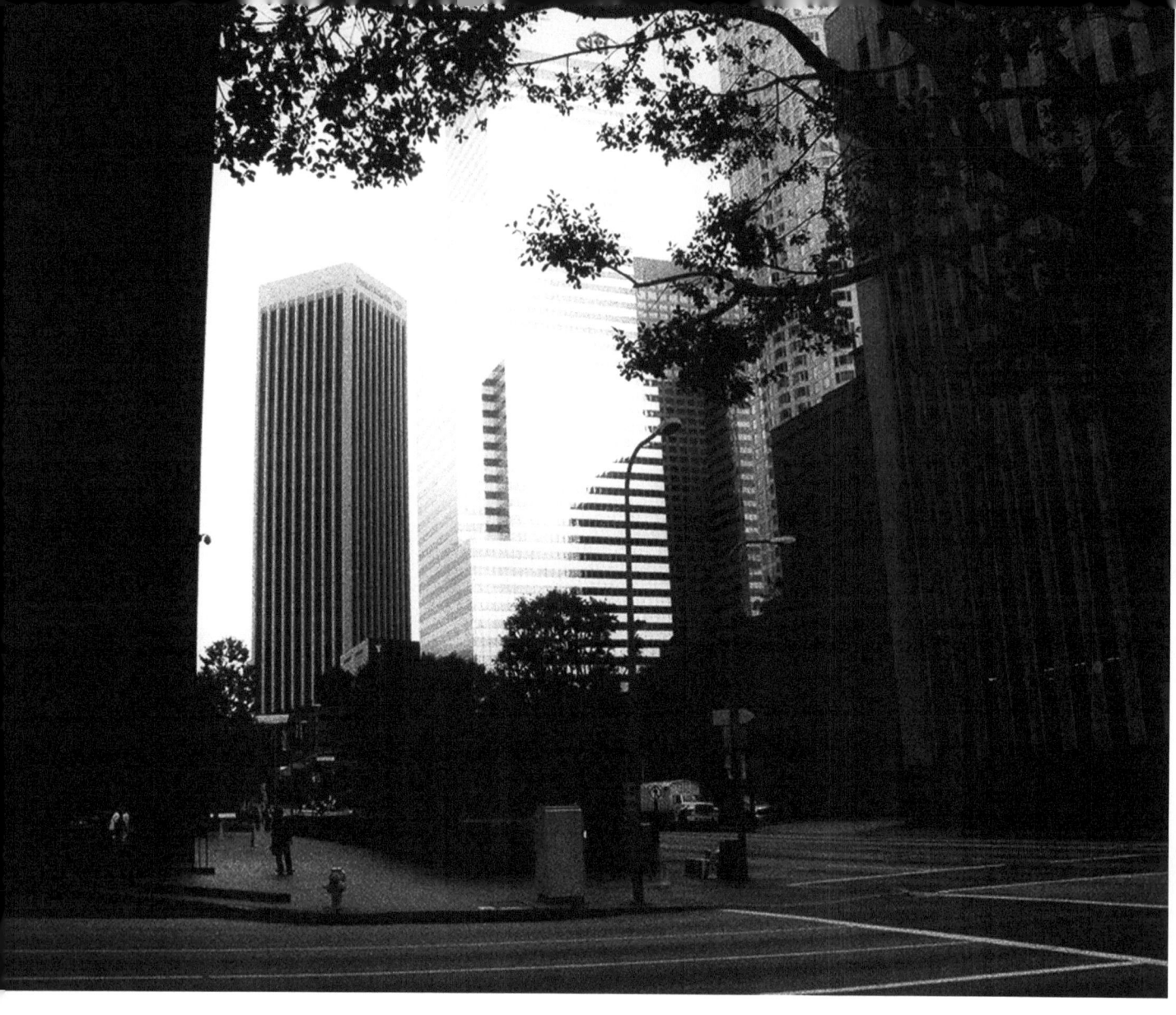

Above: 6th & STANDARD -- Loud and Silent.

Below: PAT'S PAVILLION -- This is where some woman named Pat works. This is the 4th job she's had in 20 years. Some man told her mother that she would never be allowed to do anything but clean the toilets. Now Pat, is President of West Coast Operations. Mom and Dad are well taken of... that's for sure. But poor overworked Pat.

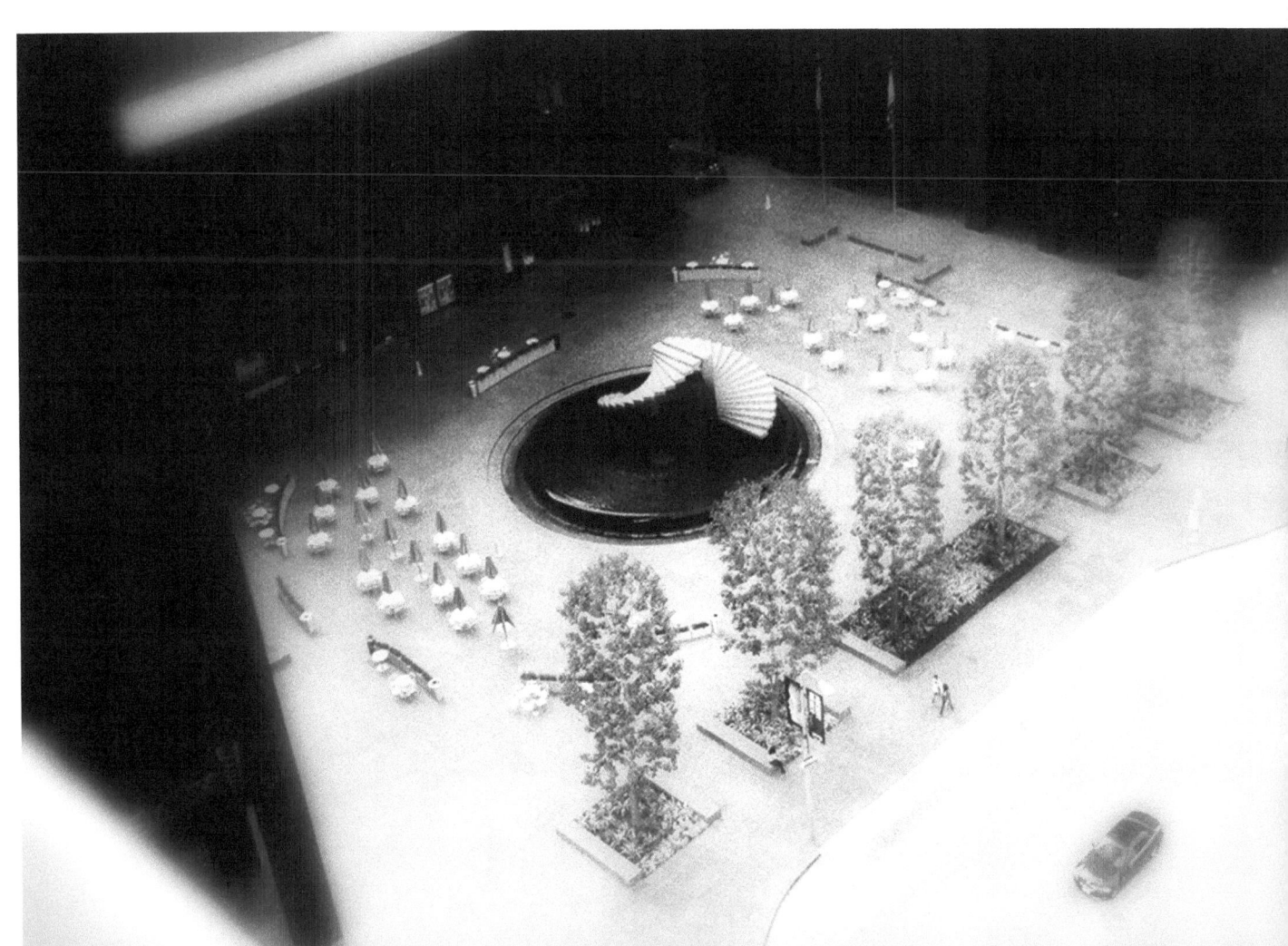

Above: a W-2 --At last!

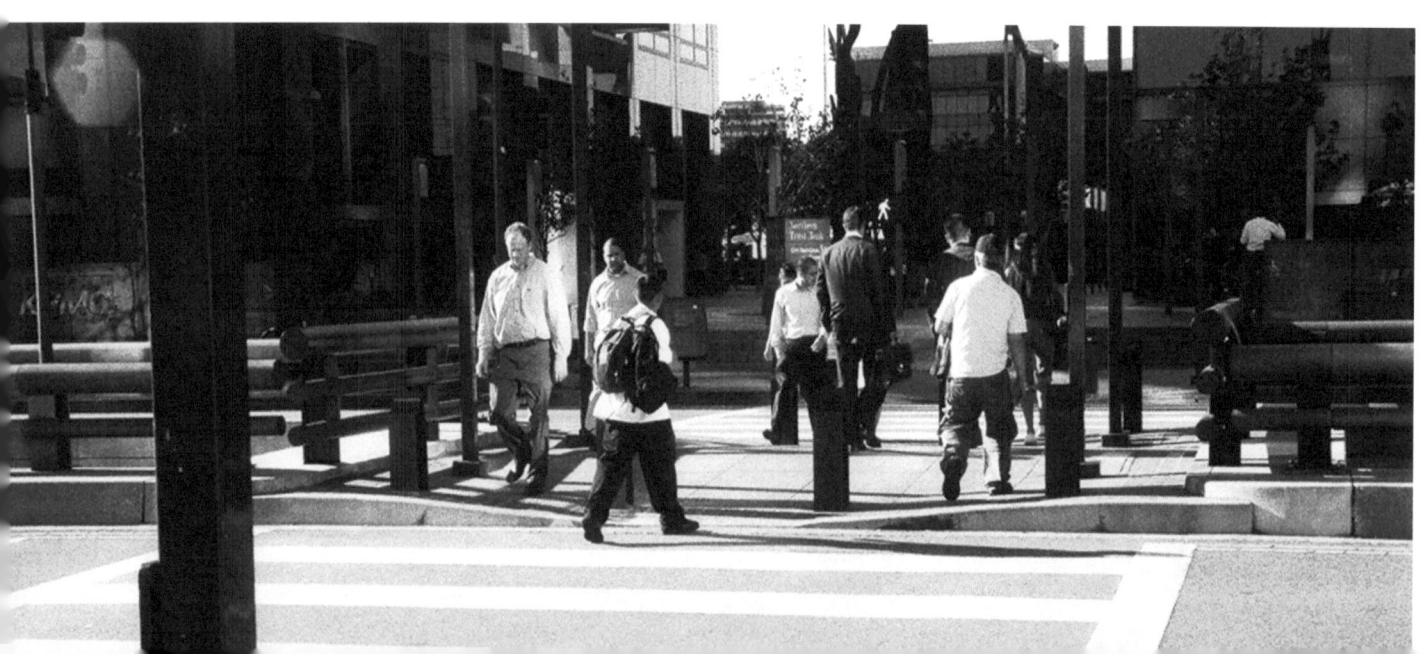

Below: HEAVY -- Pushed into his own universe.

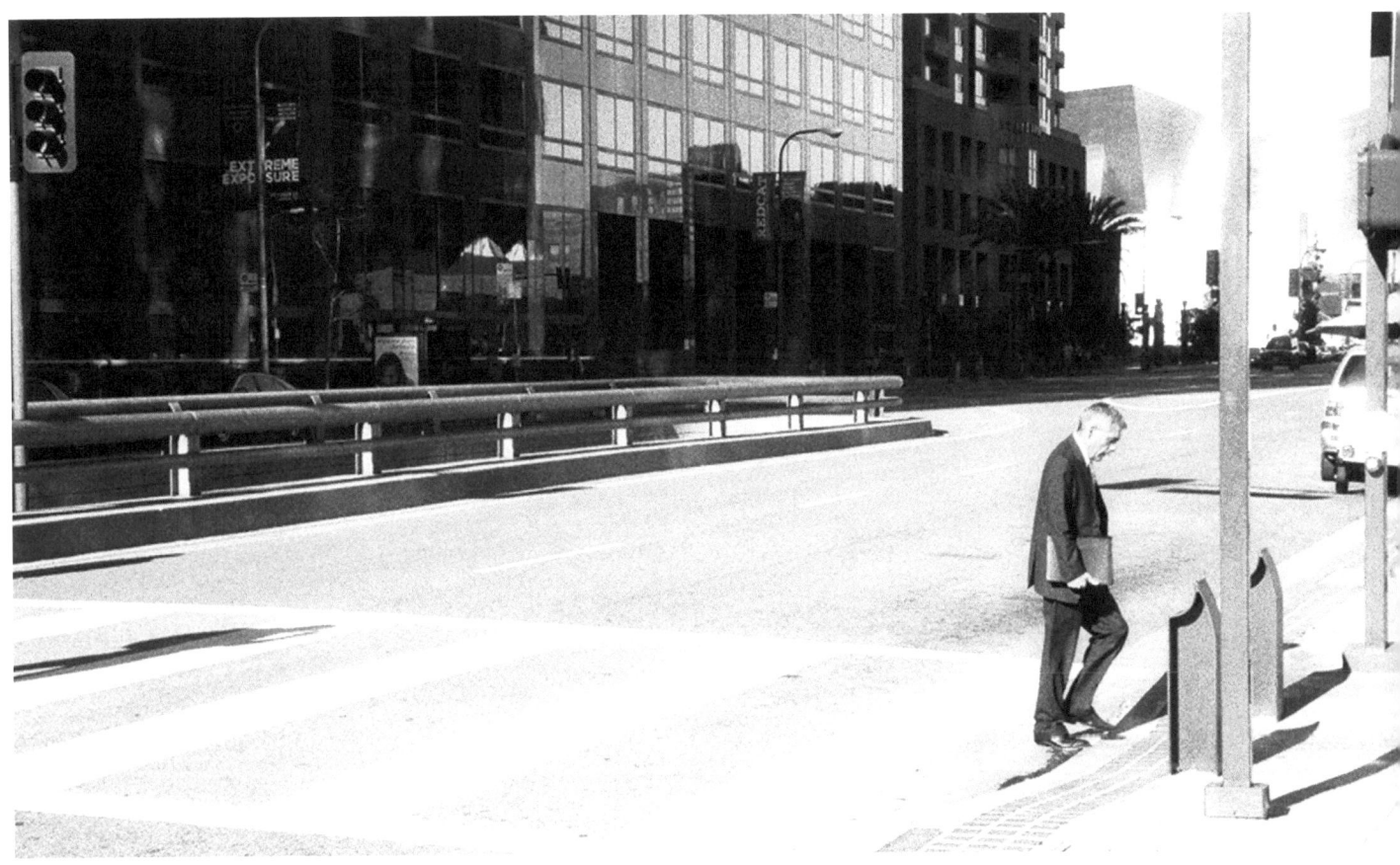

Left: ALL RELATED

Below: CLEAN

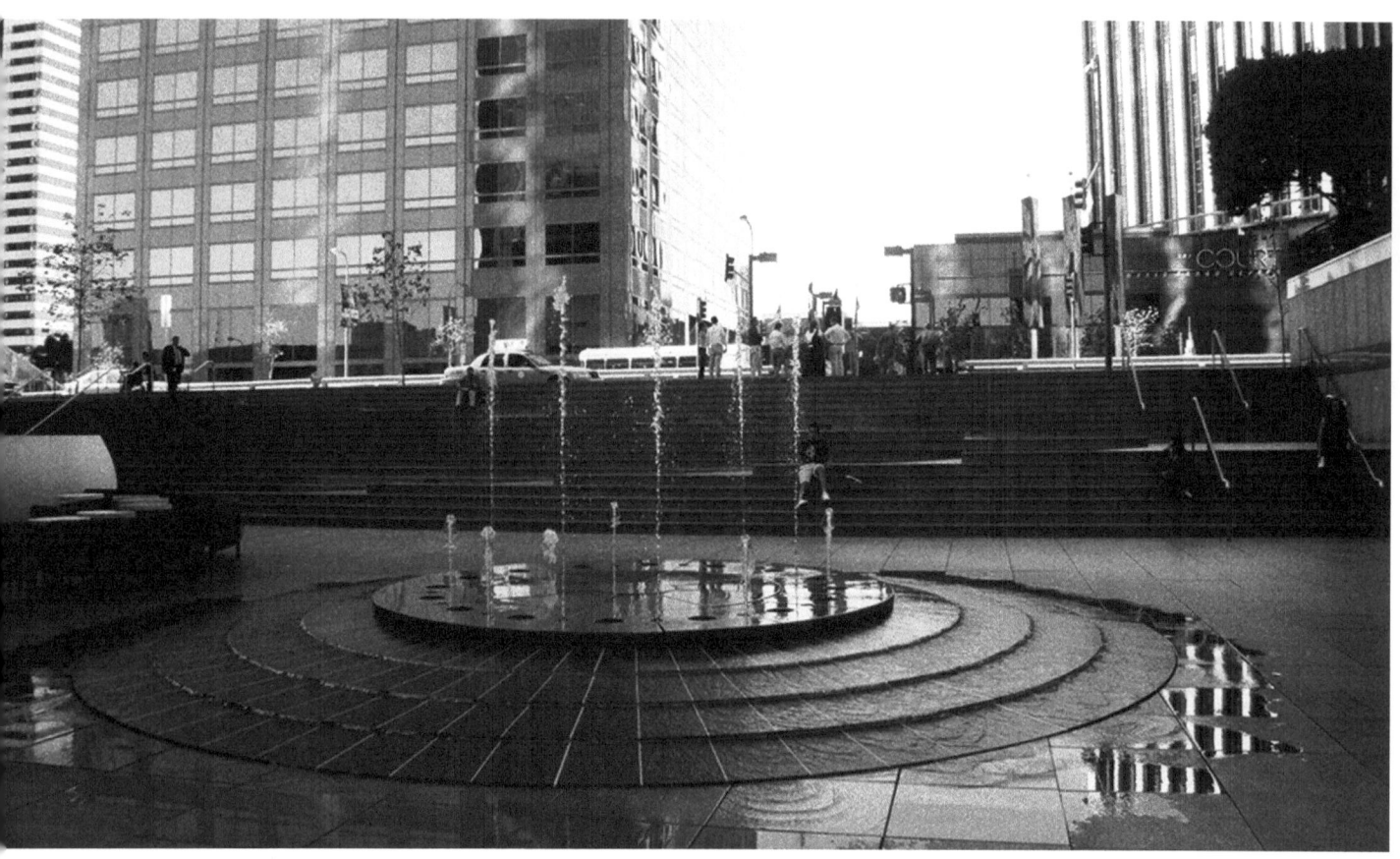

Overleaf: SEE NO COPS -- Don't even think about it. Put your token in... or else 3 Police Officers (standing to the left) will gladly do their duty.

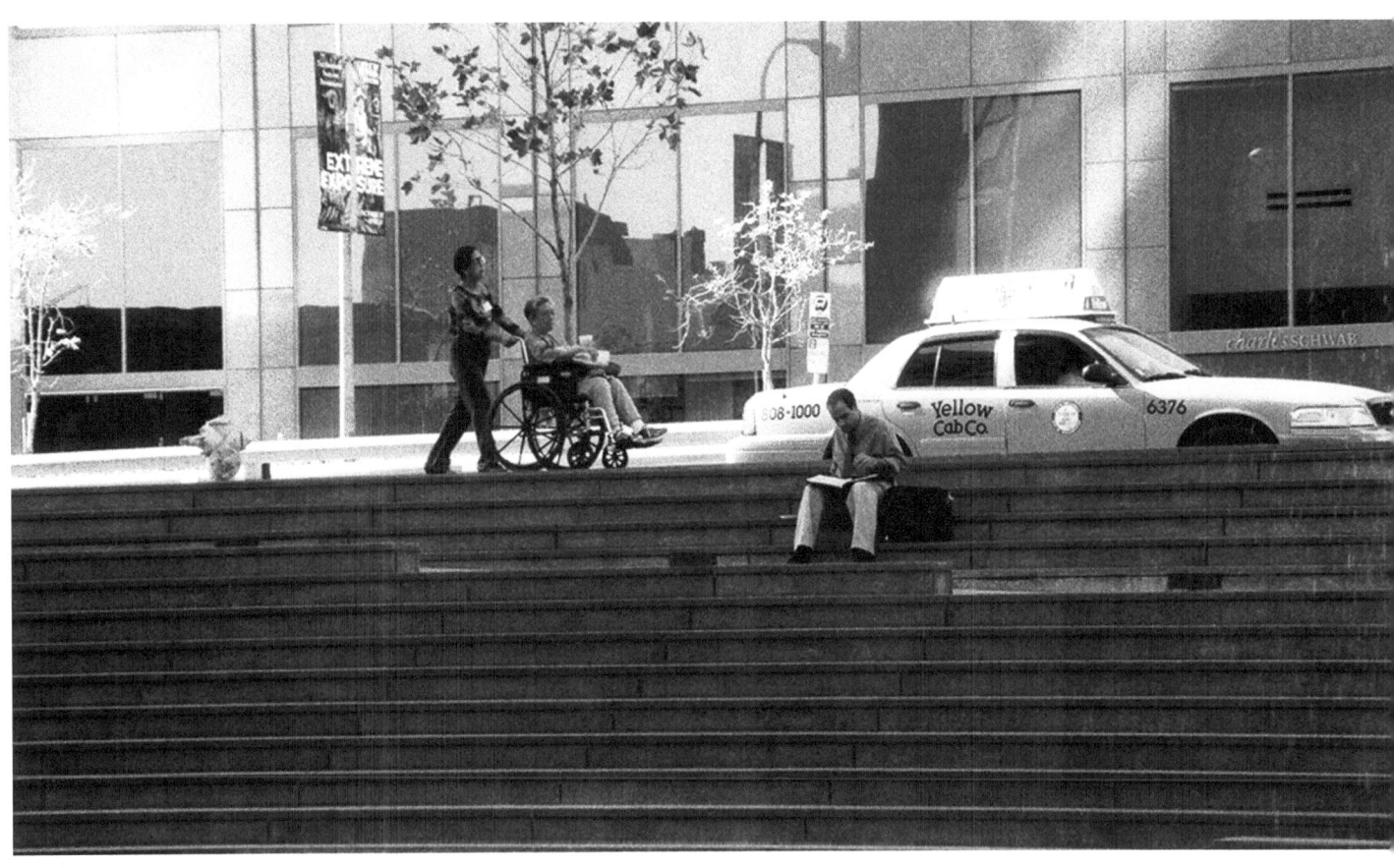

Above: FARE'S EDGE

Overleaf: OFF AT 5 -- If you're going with her, you better come on.

Below: NO CAR NOTE -- There are no private moments... only public tolerances.

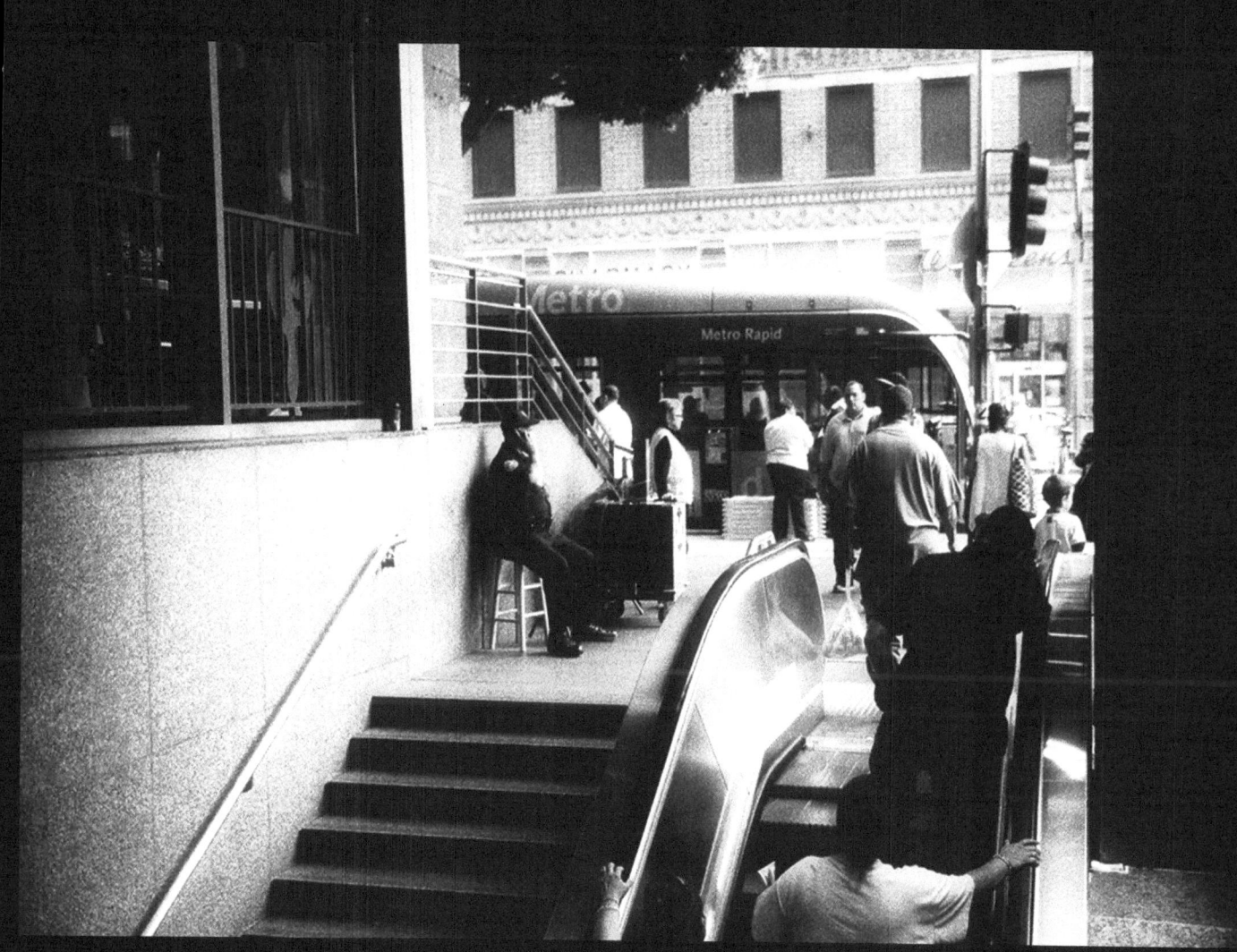

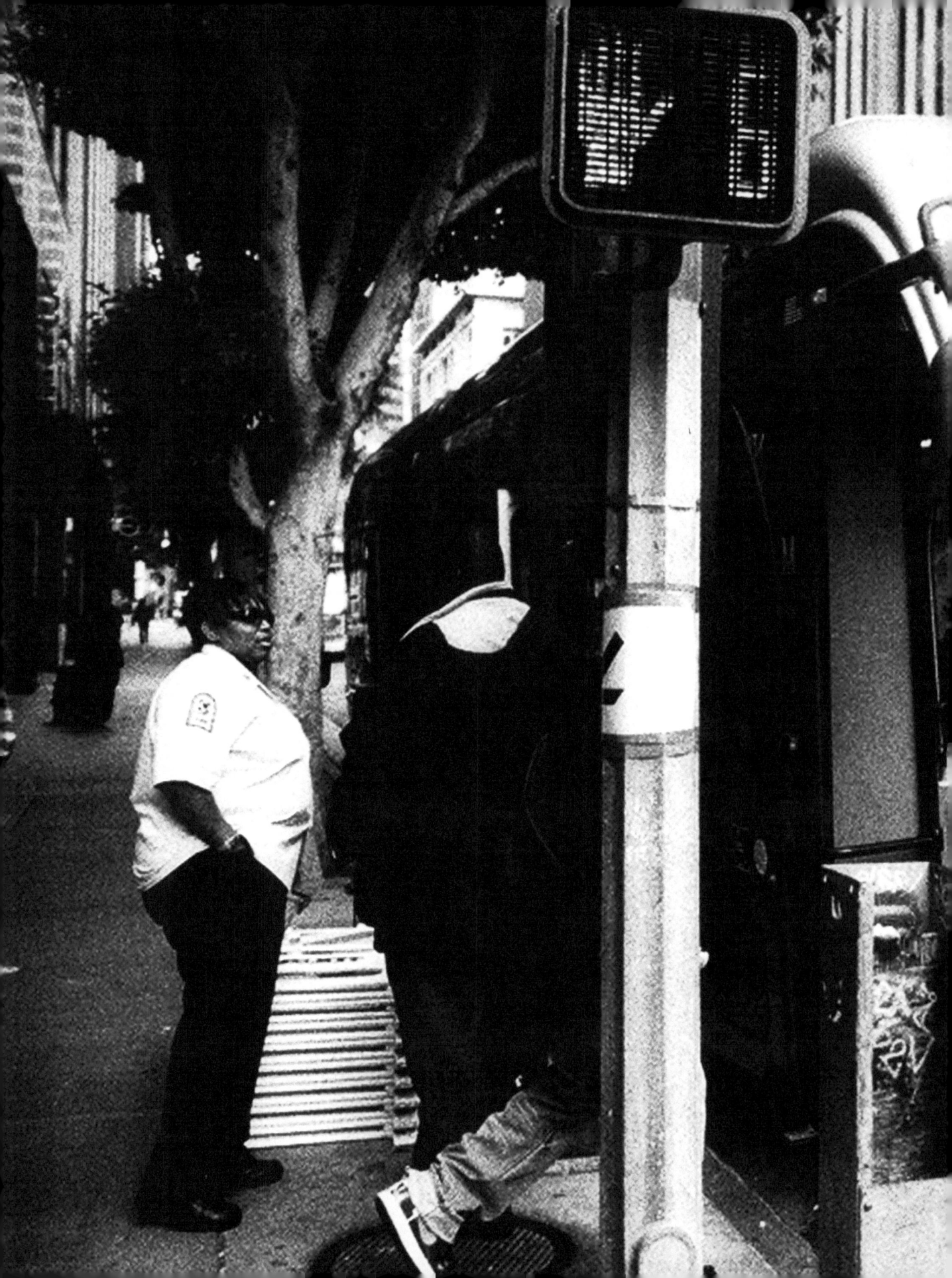

nAtUrE SuN & fReEDoM

Left: MY FOES -- Everyone wants some of her power.

Overleaf: I WIN -- The right voice is heard.

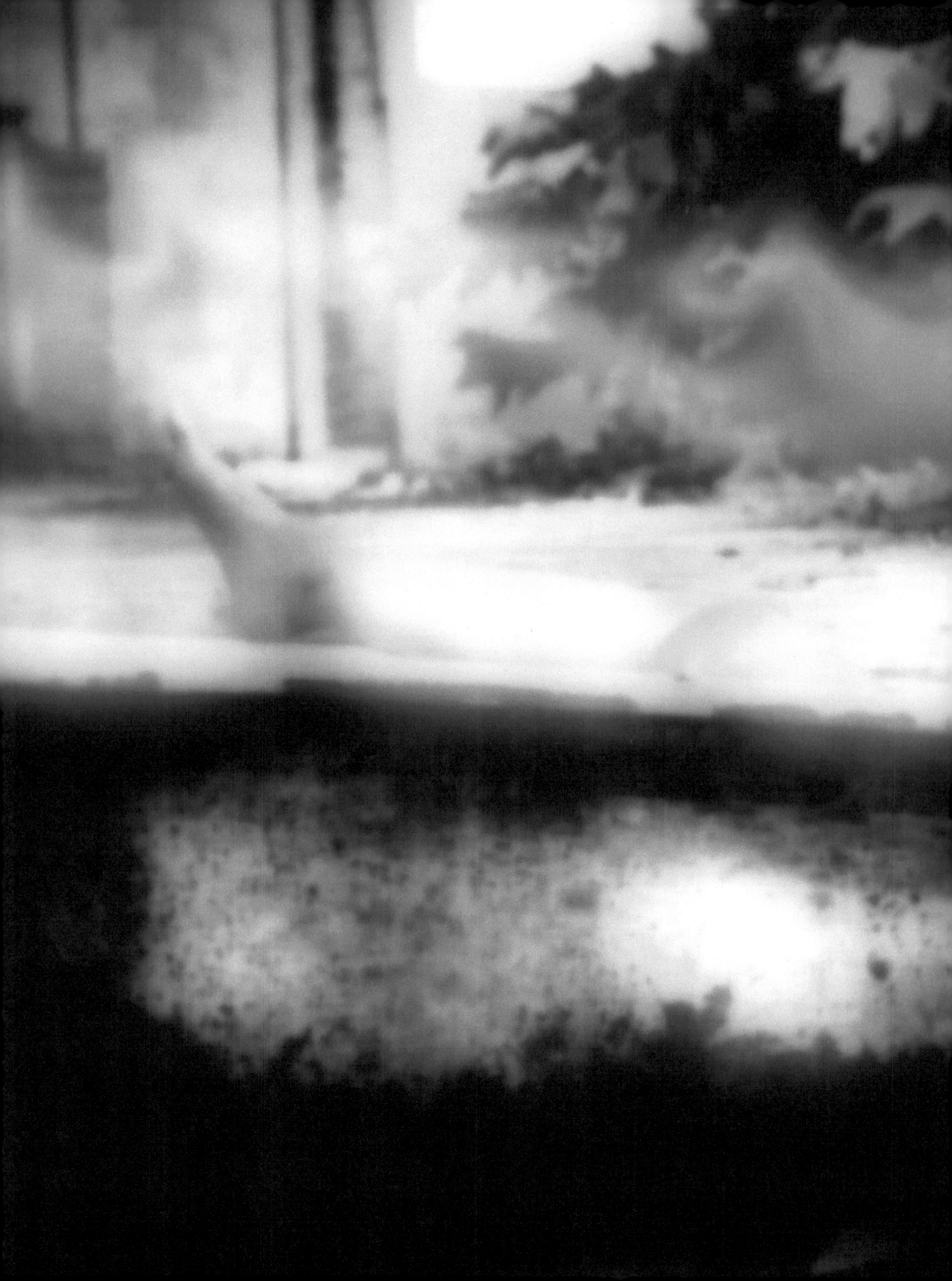

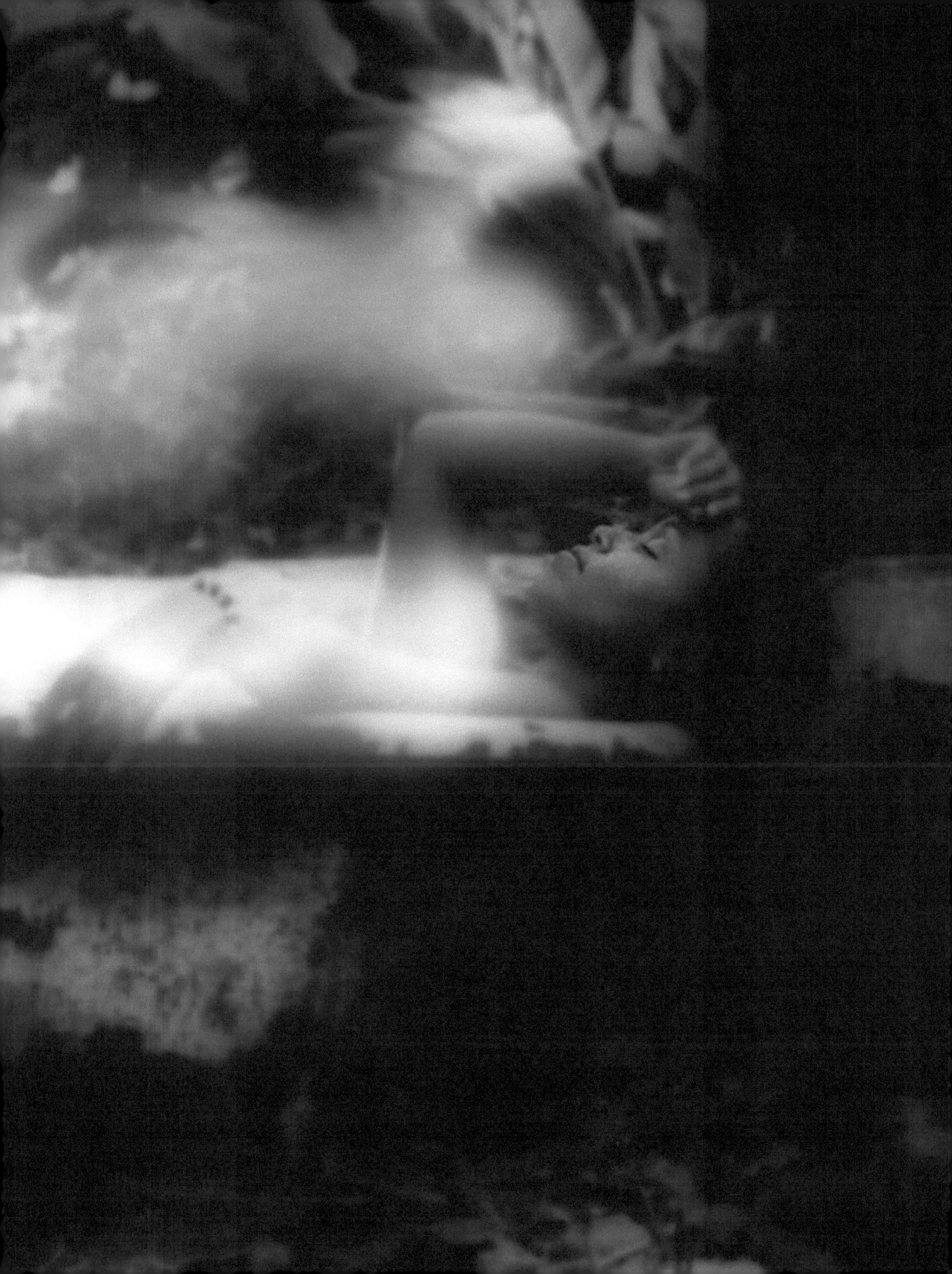

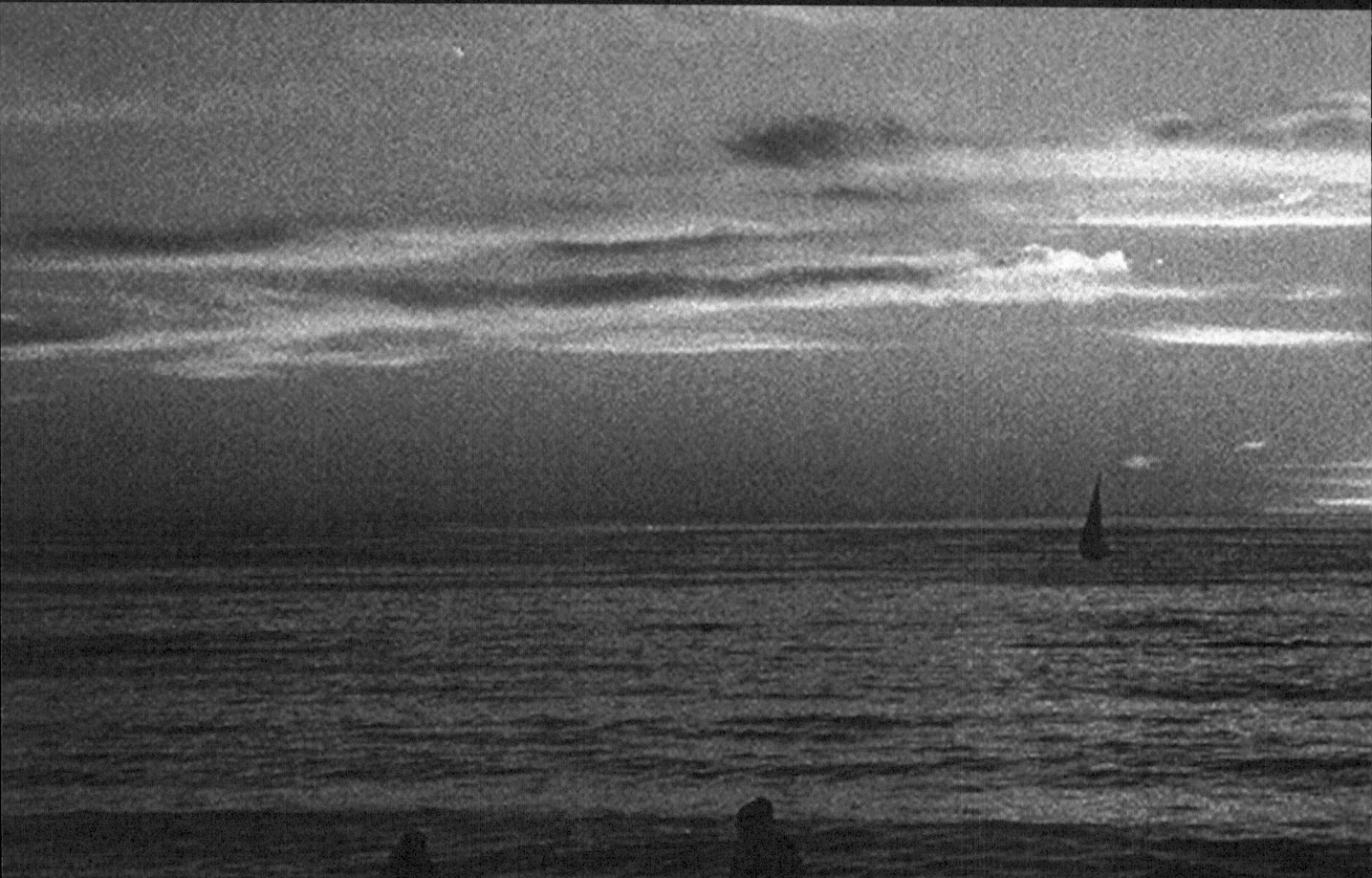

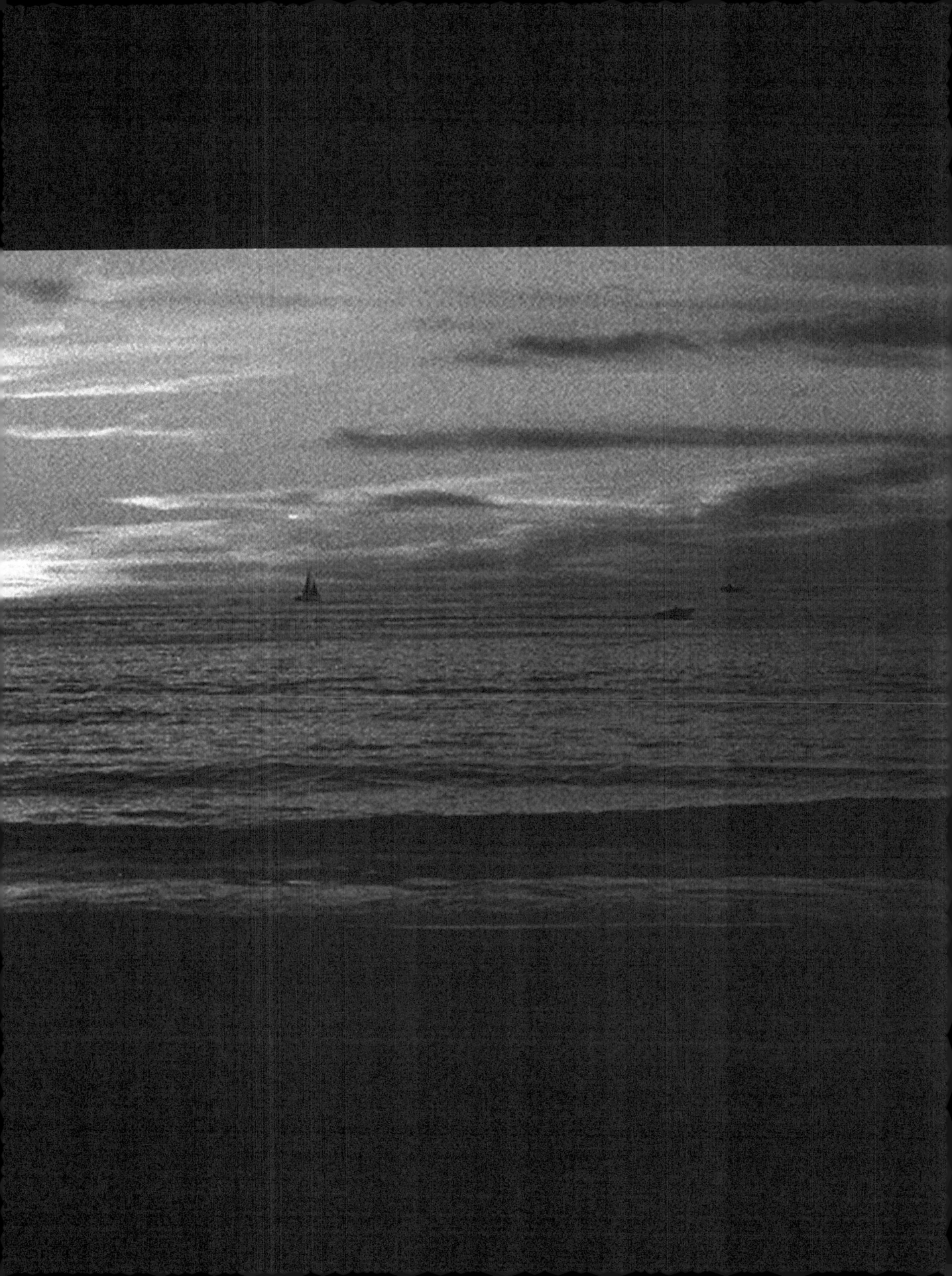

Top Right: SO WARM -- The envy of a tender moment.

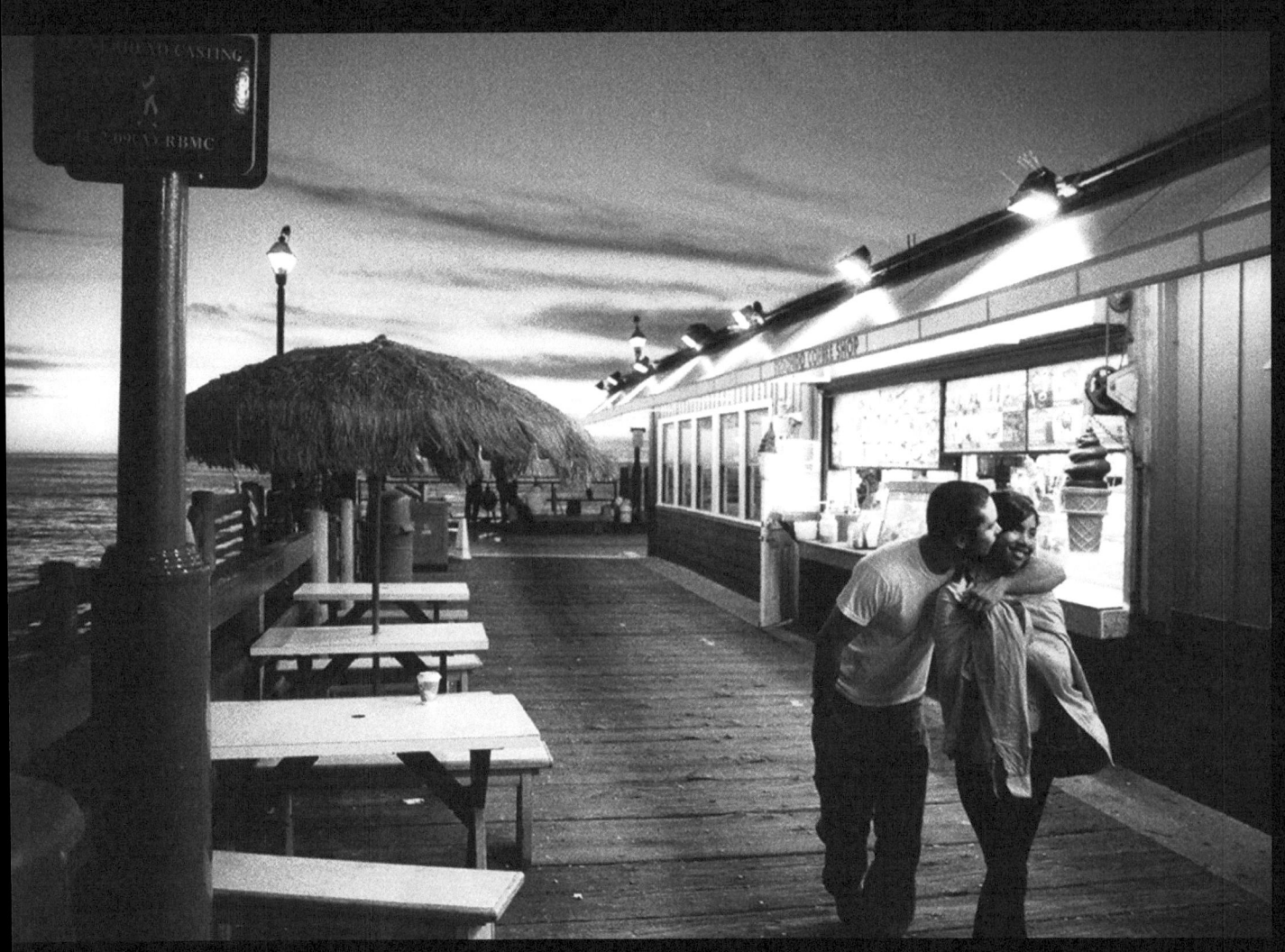

Bottom Right: THE PIER -- Take me to the end.

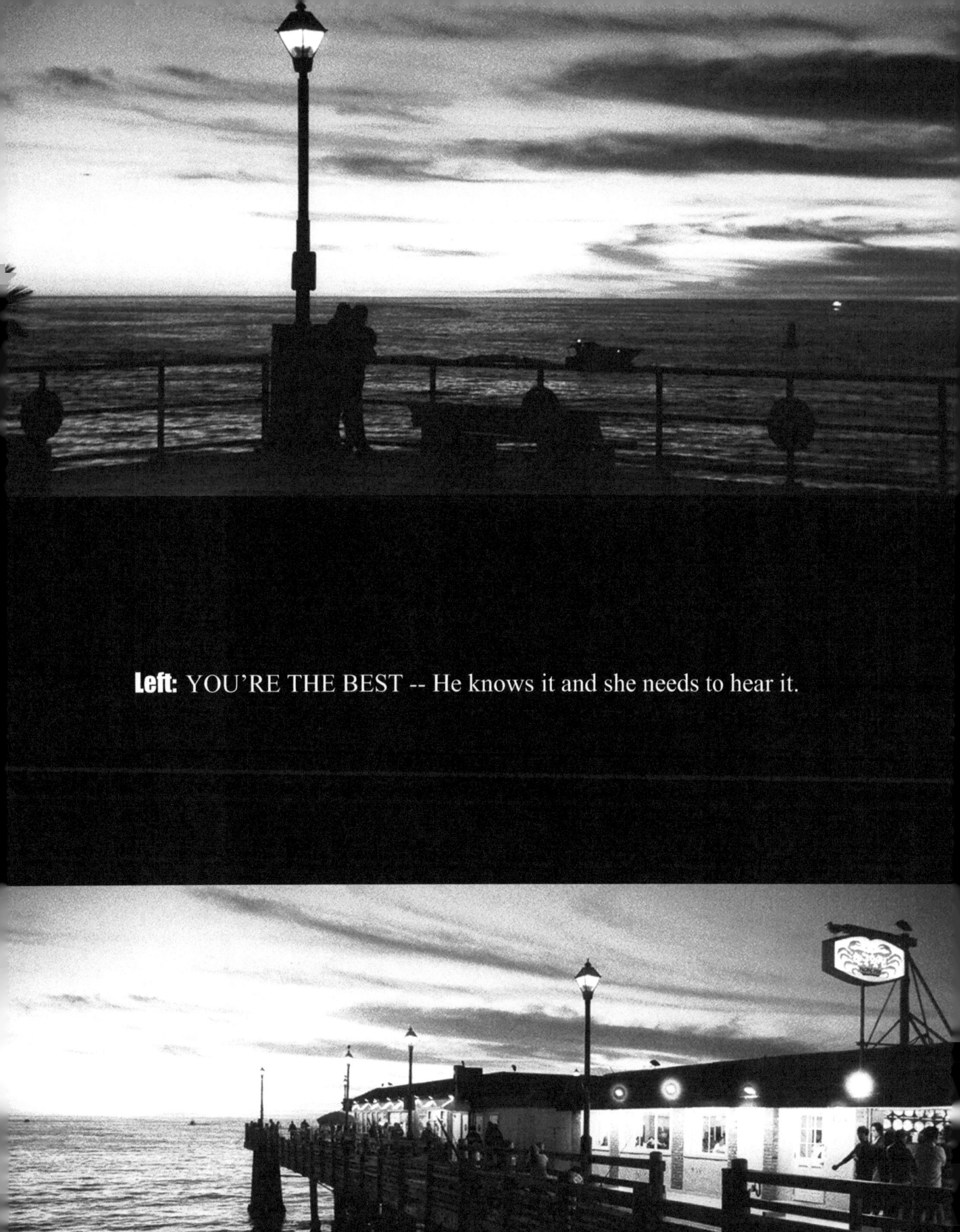

Left: YOU'RE THE BEST -- He knows it and she needs to hear it.

Above: HAPPY GIRLS -- They will reflect on this when they're 65.

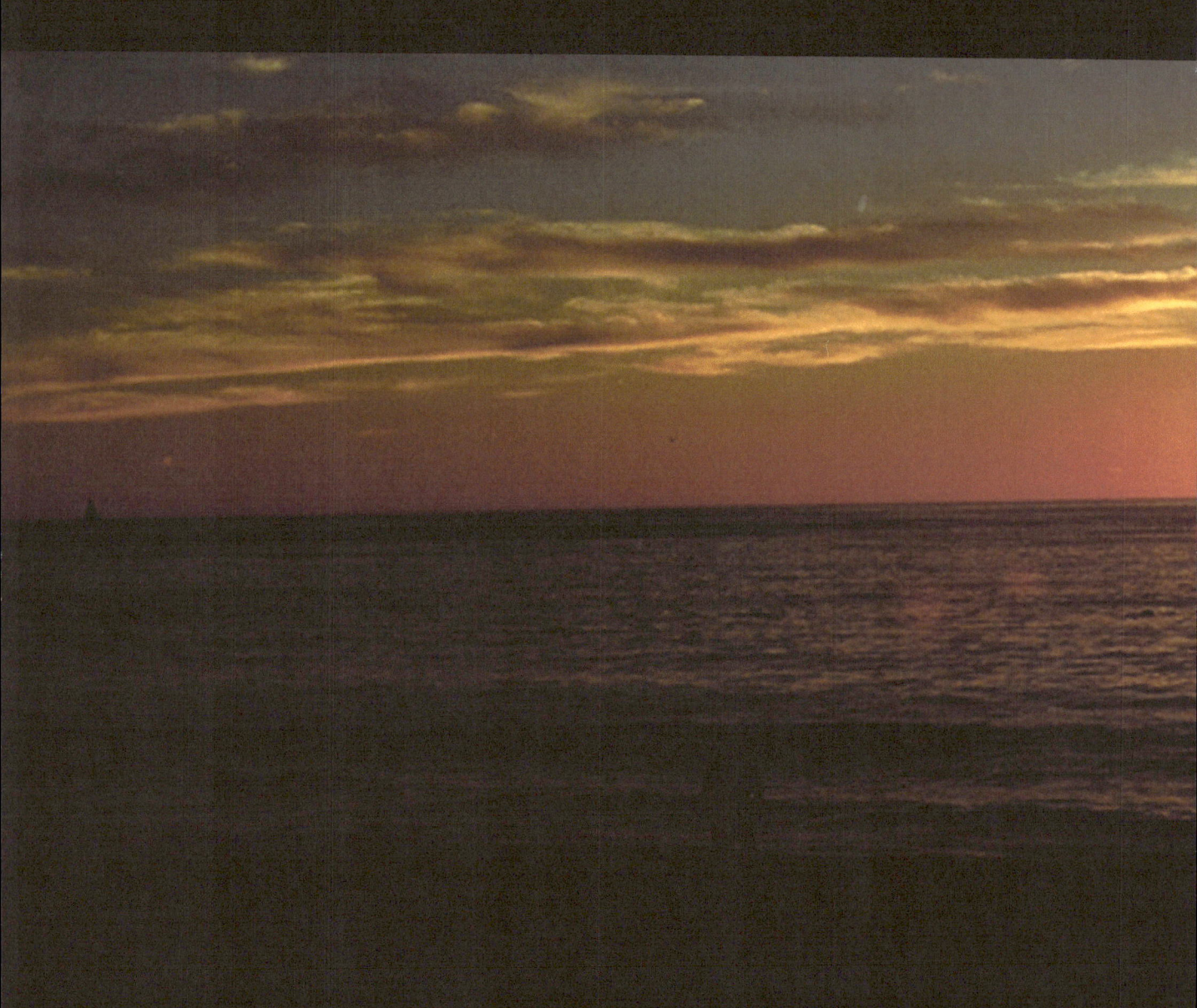

Below: FACE THE SUN -- He was left alone to his thoughts.

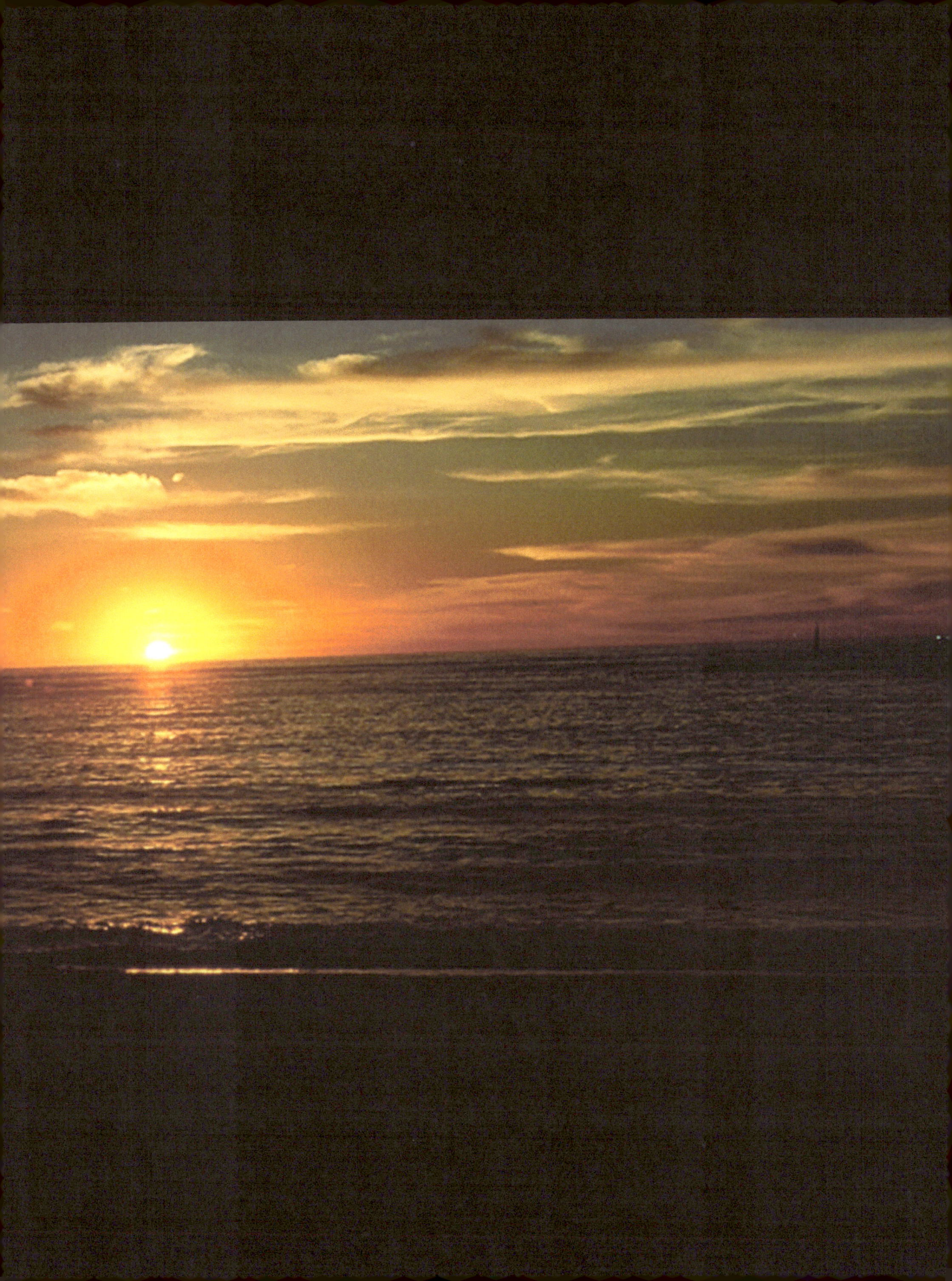

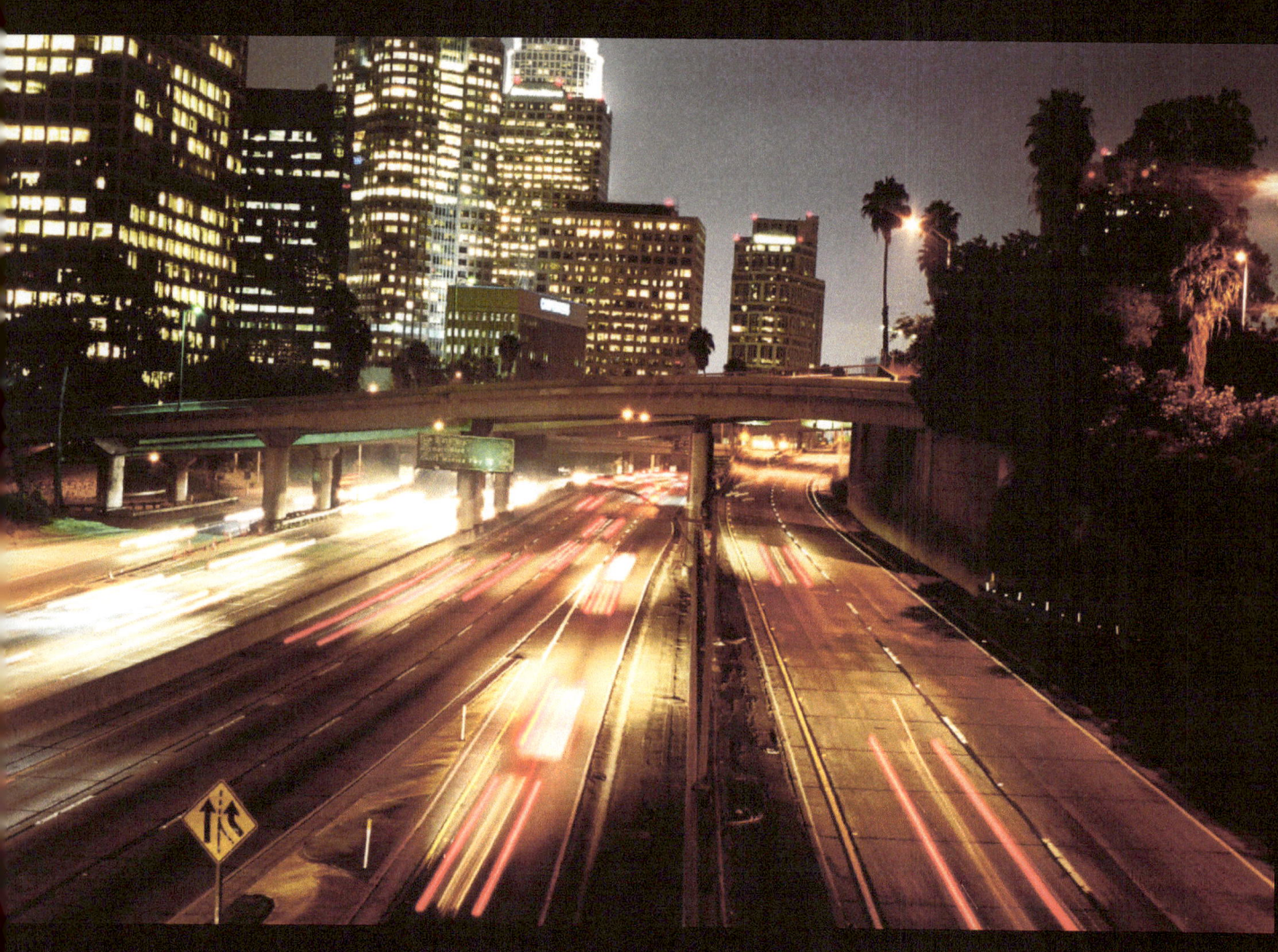

DOWNTOWN NOCTURNAL

Left: RACE HOME -- Everyone has somewhere to be.

Right: ABANDON -- The danger was expected. But the curiousity made her linger.

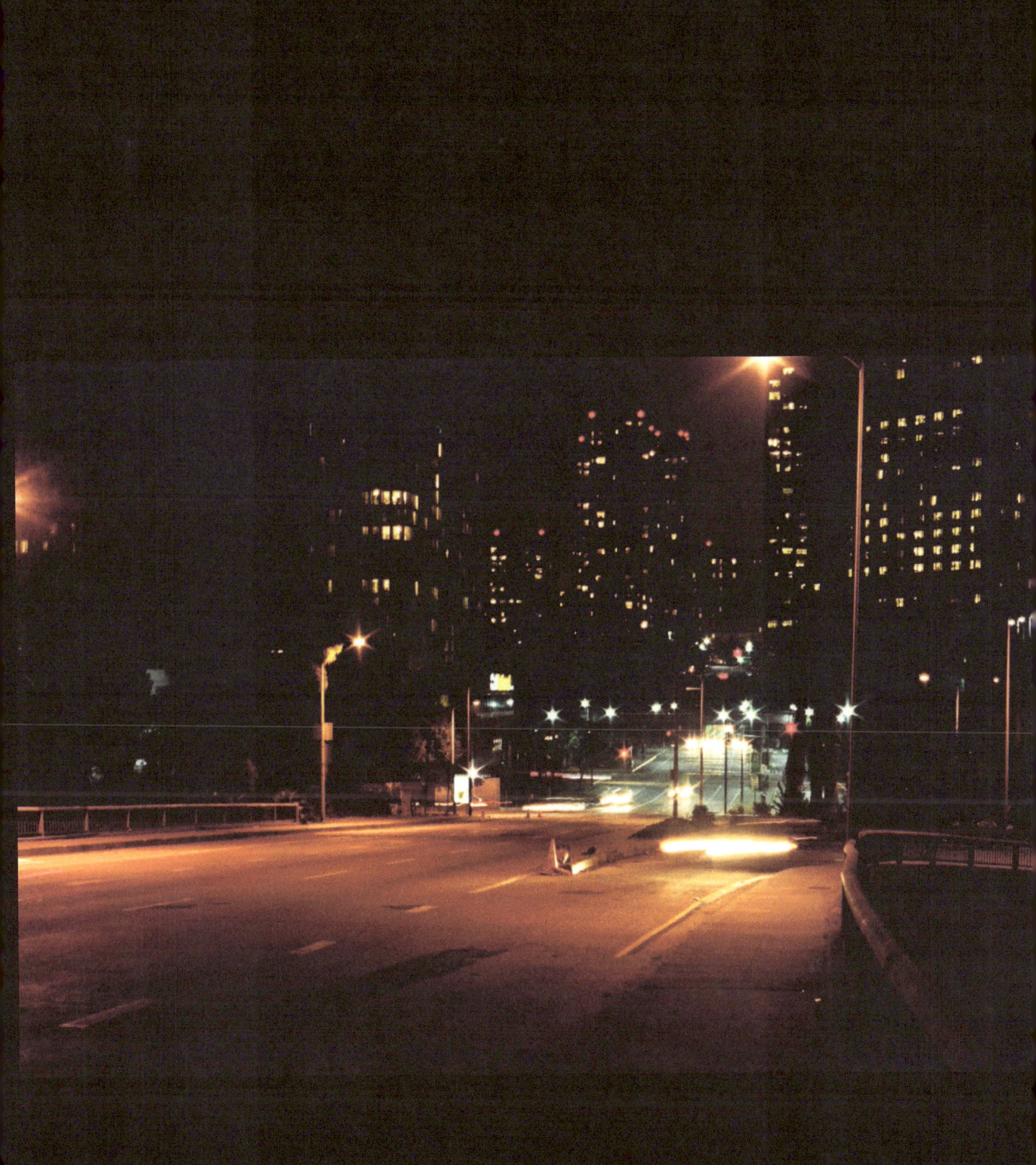

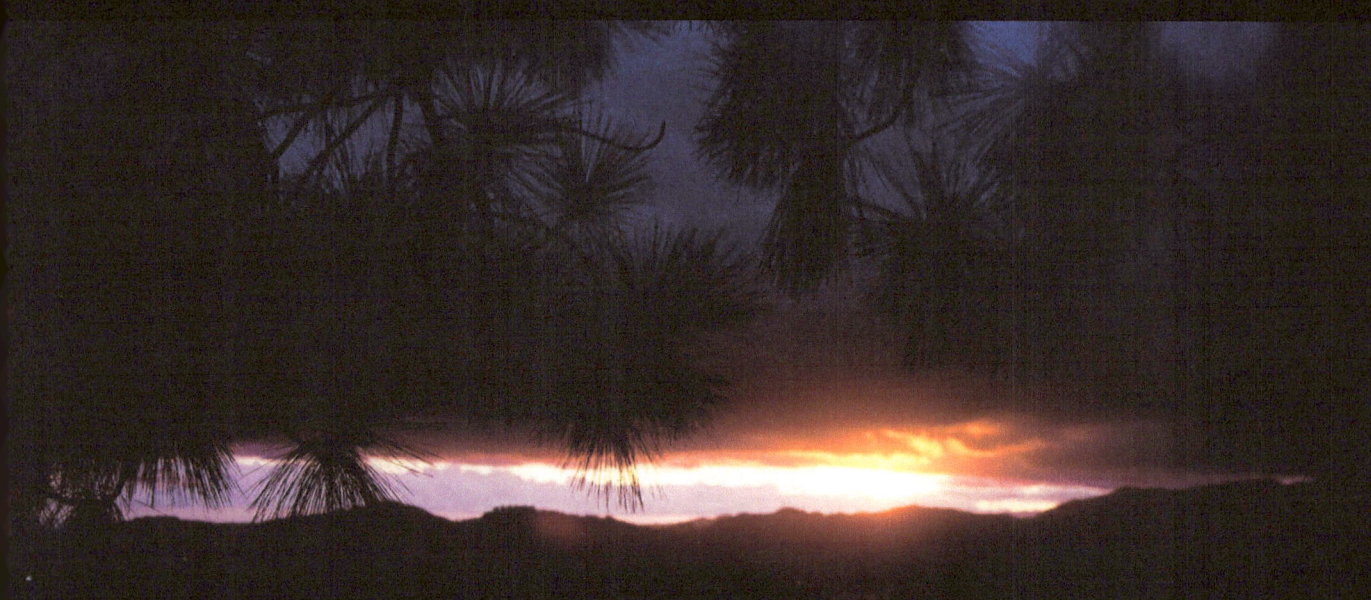

MEET THE CLOUDS

Left: LAYERS (Series) -I was bringing the garbage cans off the street around 5'ish... I come outside and see a breathtaking composition: The Sun, a dense formation of overcast clouds, and a thin horizontal layer of sky... intentionally orchastrated. I had to get into the car, load my camera, and get as far up as possible. But I only had minutes before it all went dark. It seemed like everything was waiting on me.

Overleaf: LAYERS (Heavy Hot) -- I am half way to where I need to be but I had to pull over, get out of the car, and snatch the first moment.

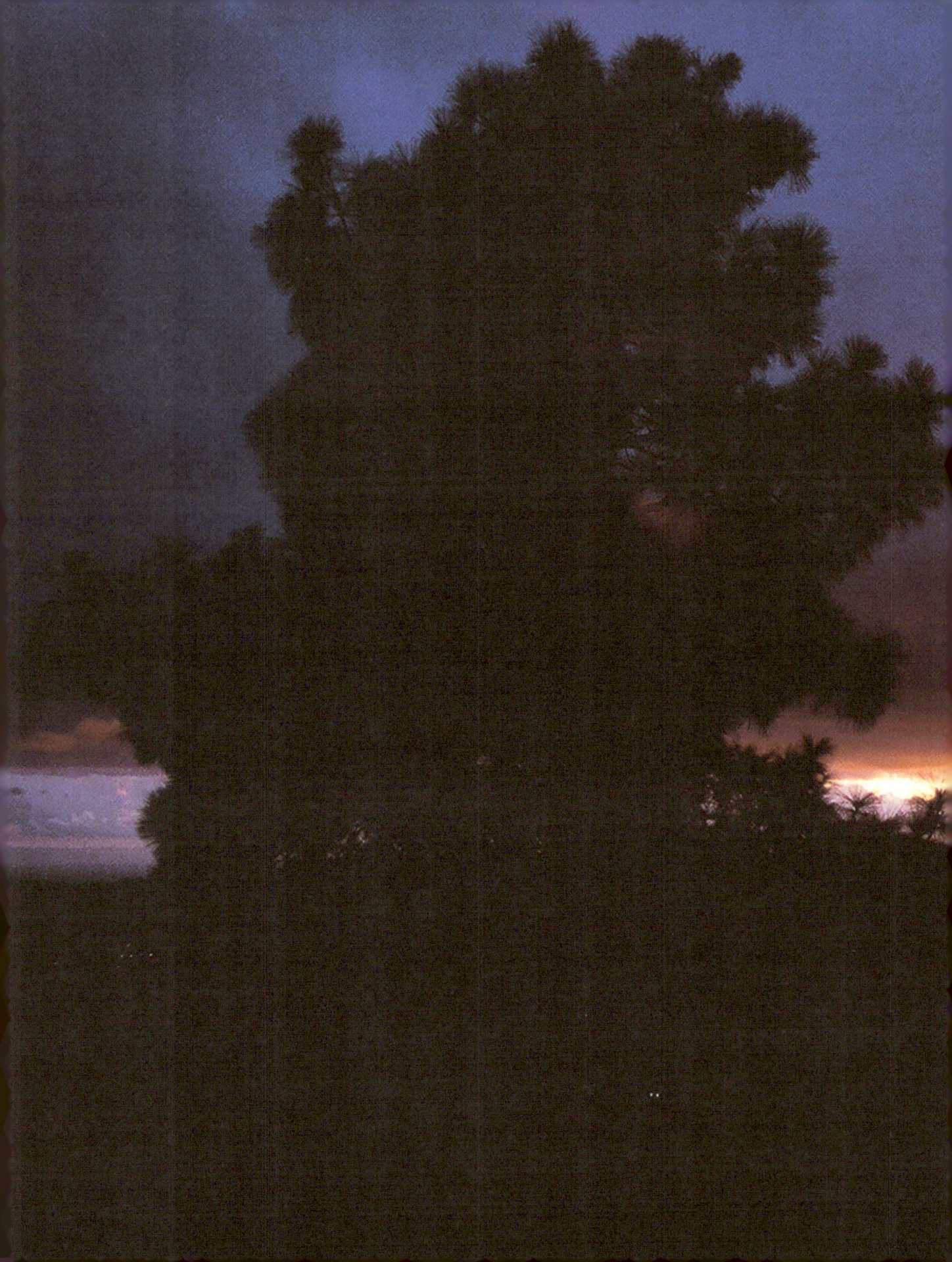

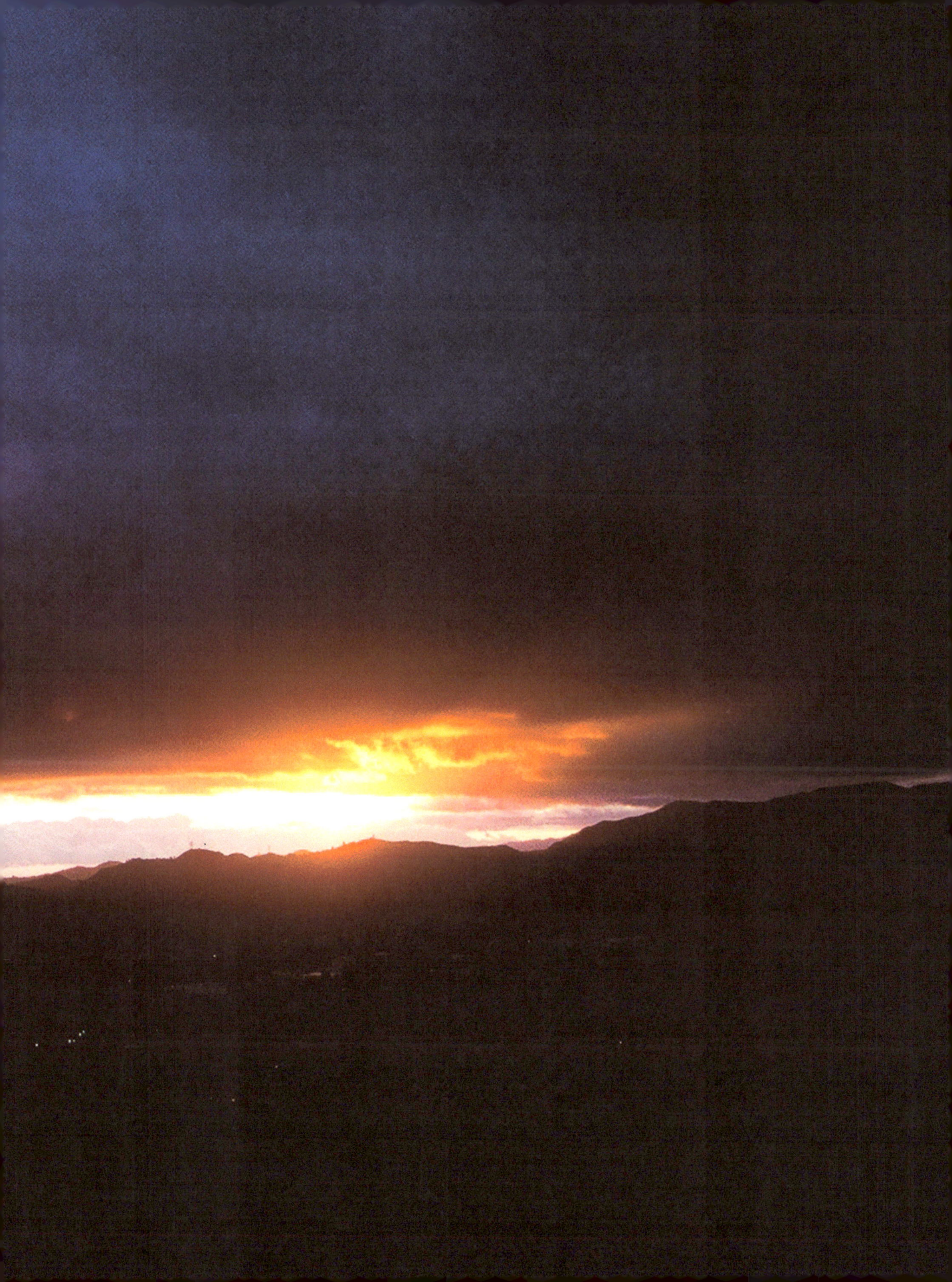

Here: LAYERS (The Ceiling) -- The strength of darkness pushes the Sun to Malibu.

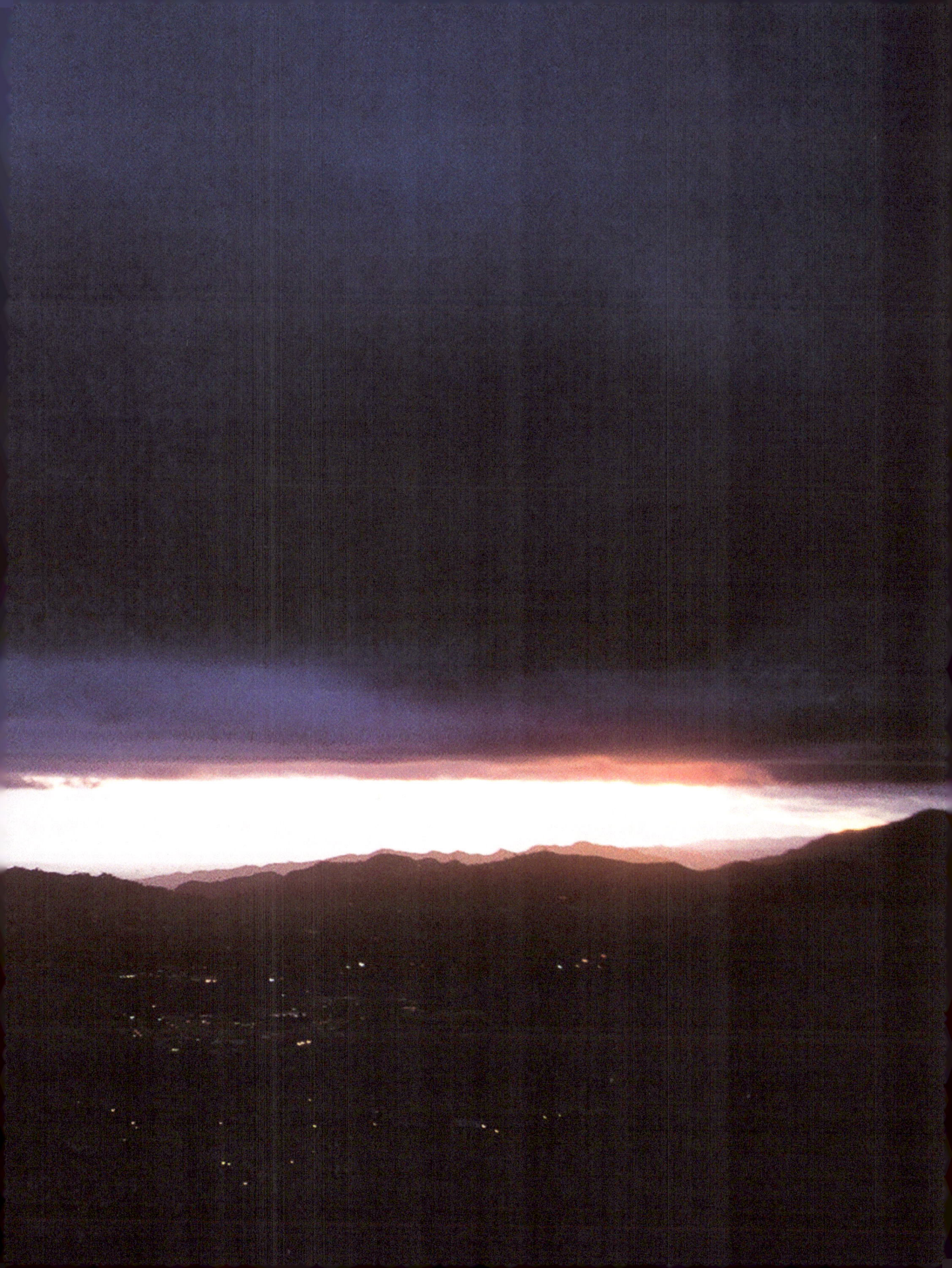

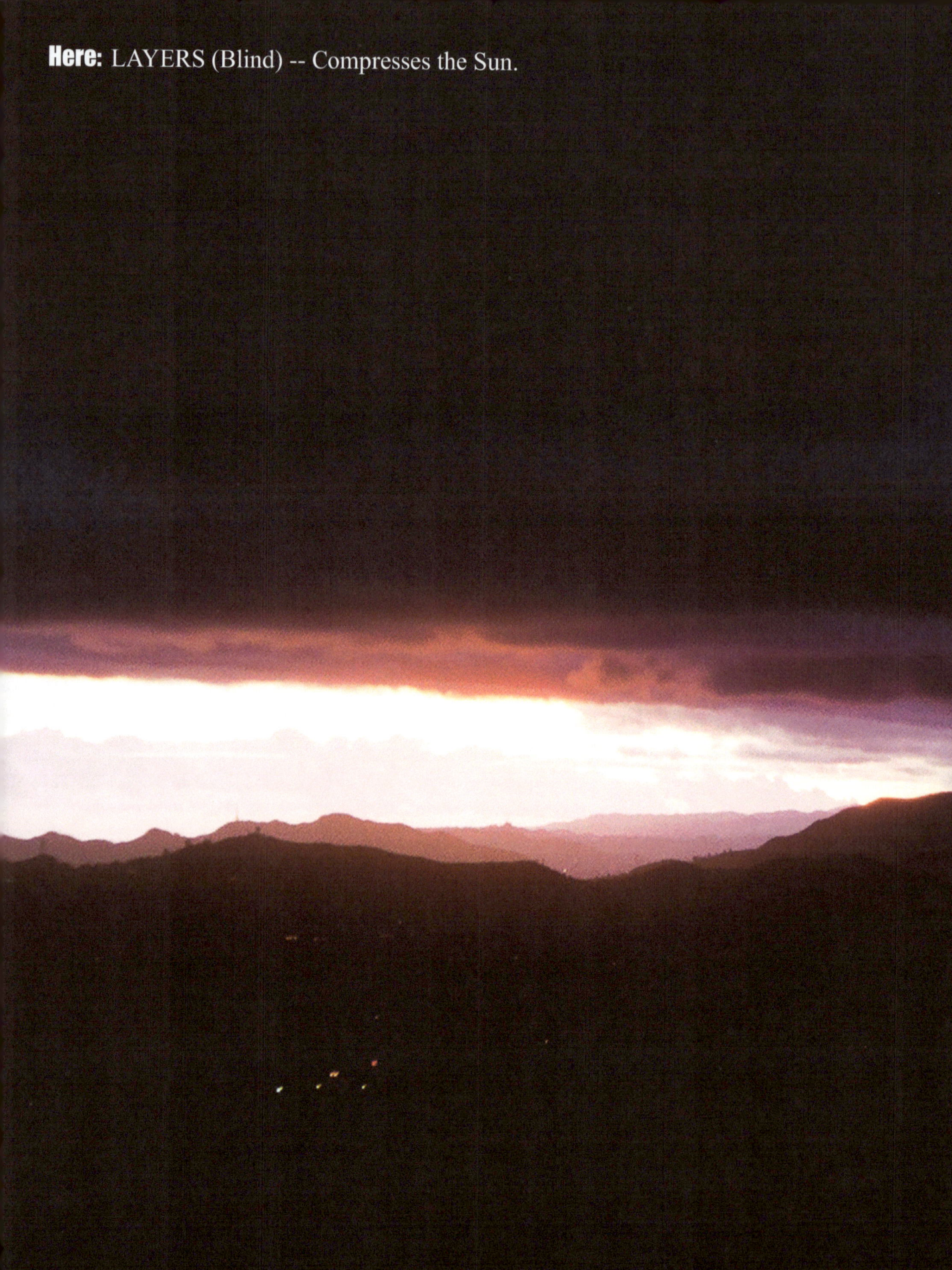

Here: LAYERS (Blind) -- Compresses the Sun.

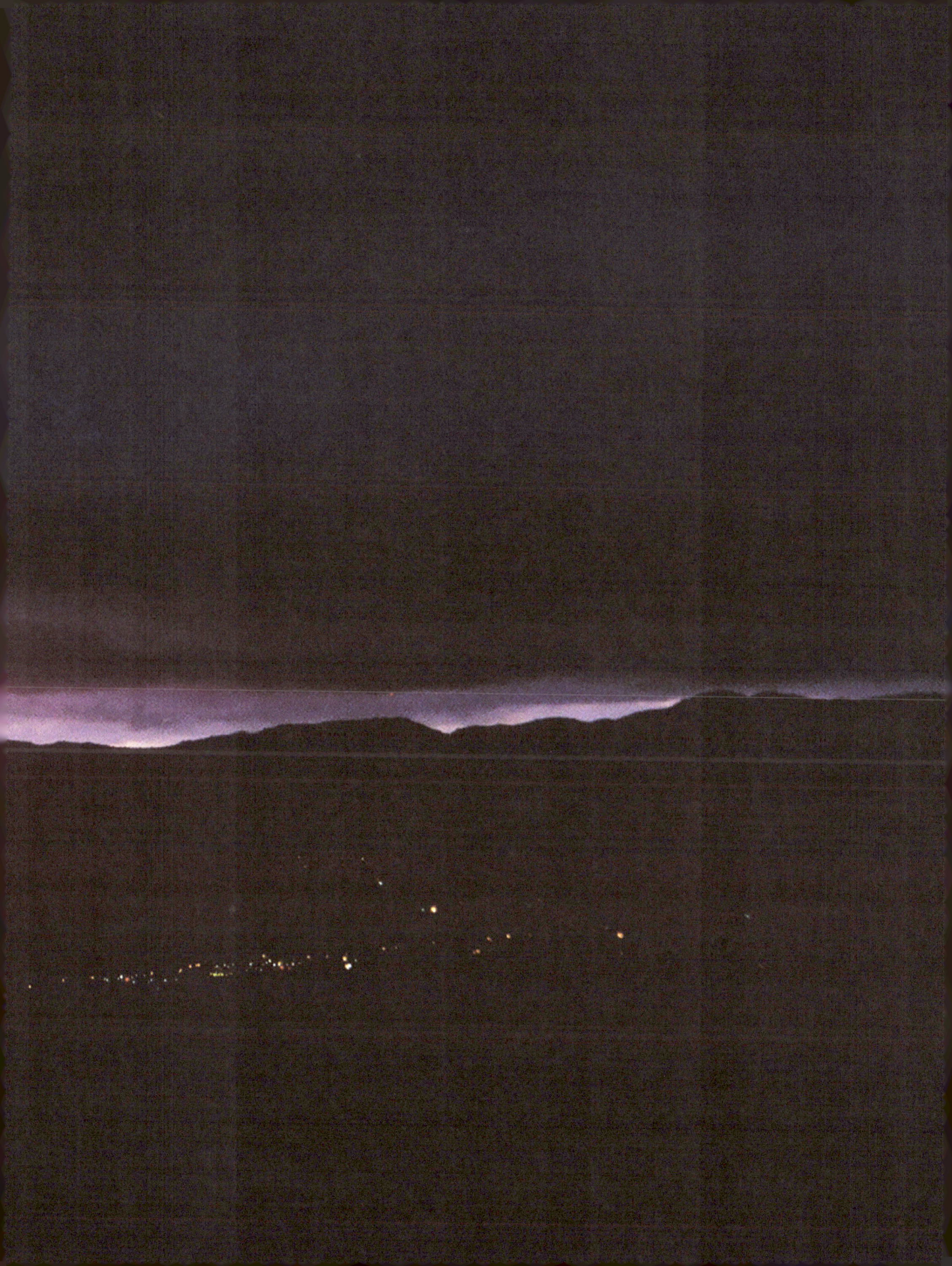

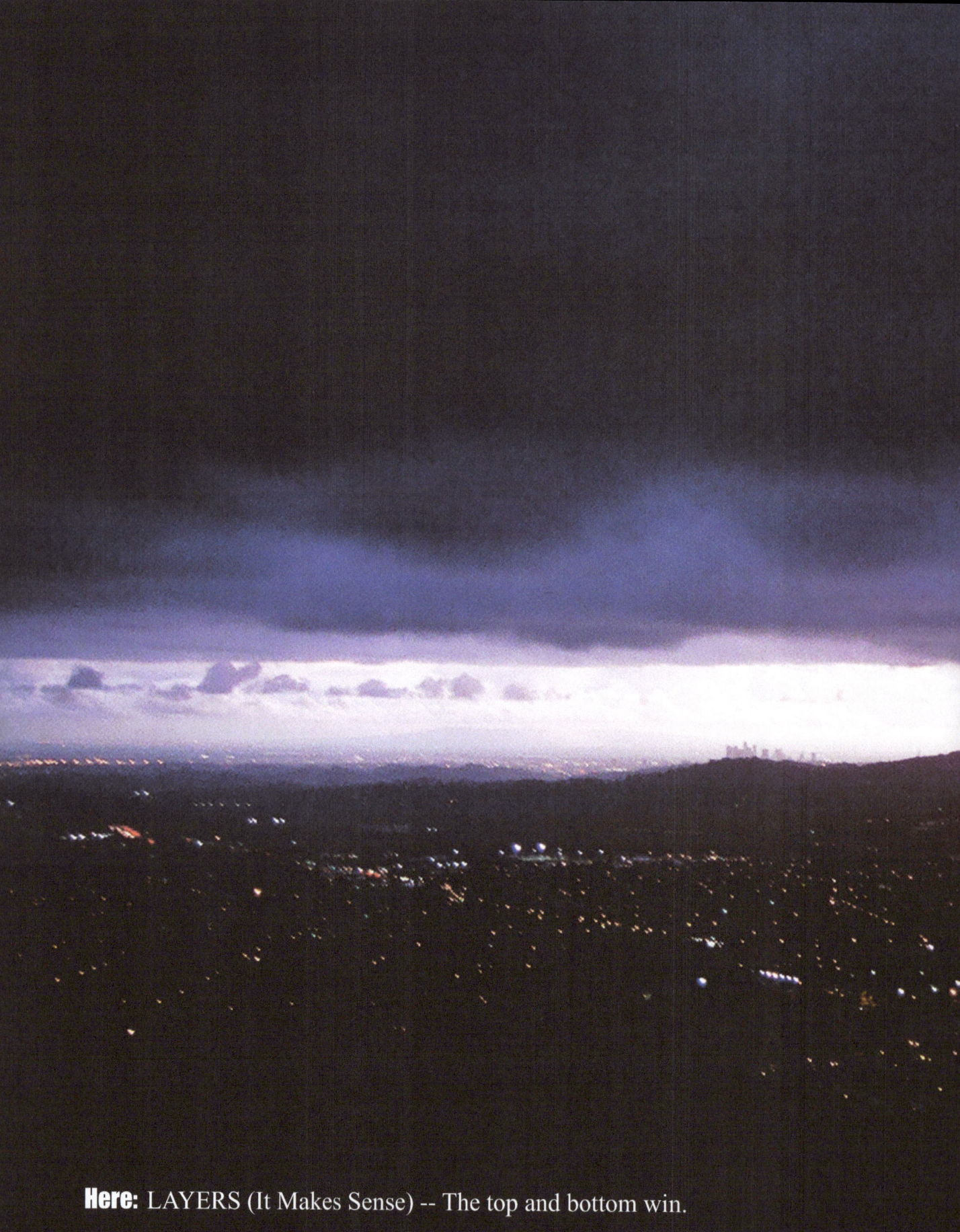

Here: LAYERS (It Makes Sense) -- The top and bottom win.

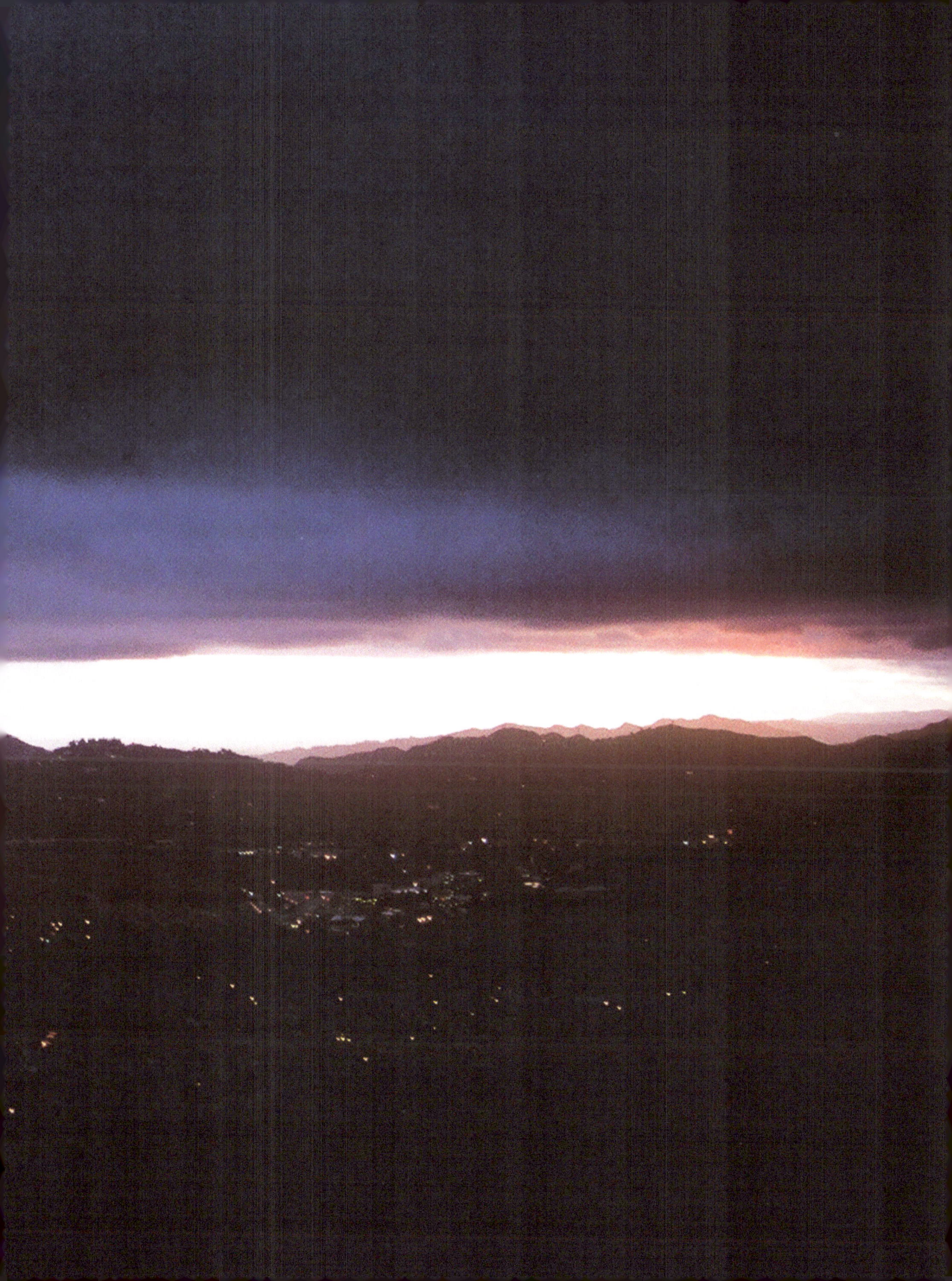

Below & Right: MISTY CRISP -- Beauty destroyed. The smallest branches were crying out.

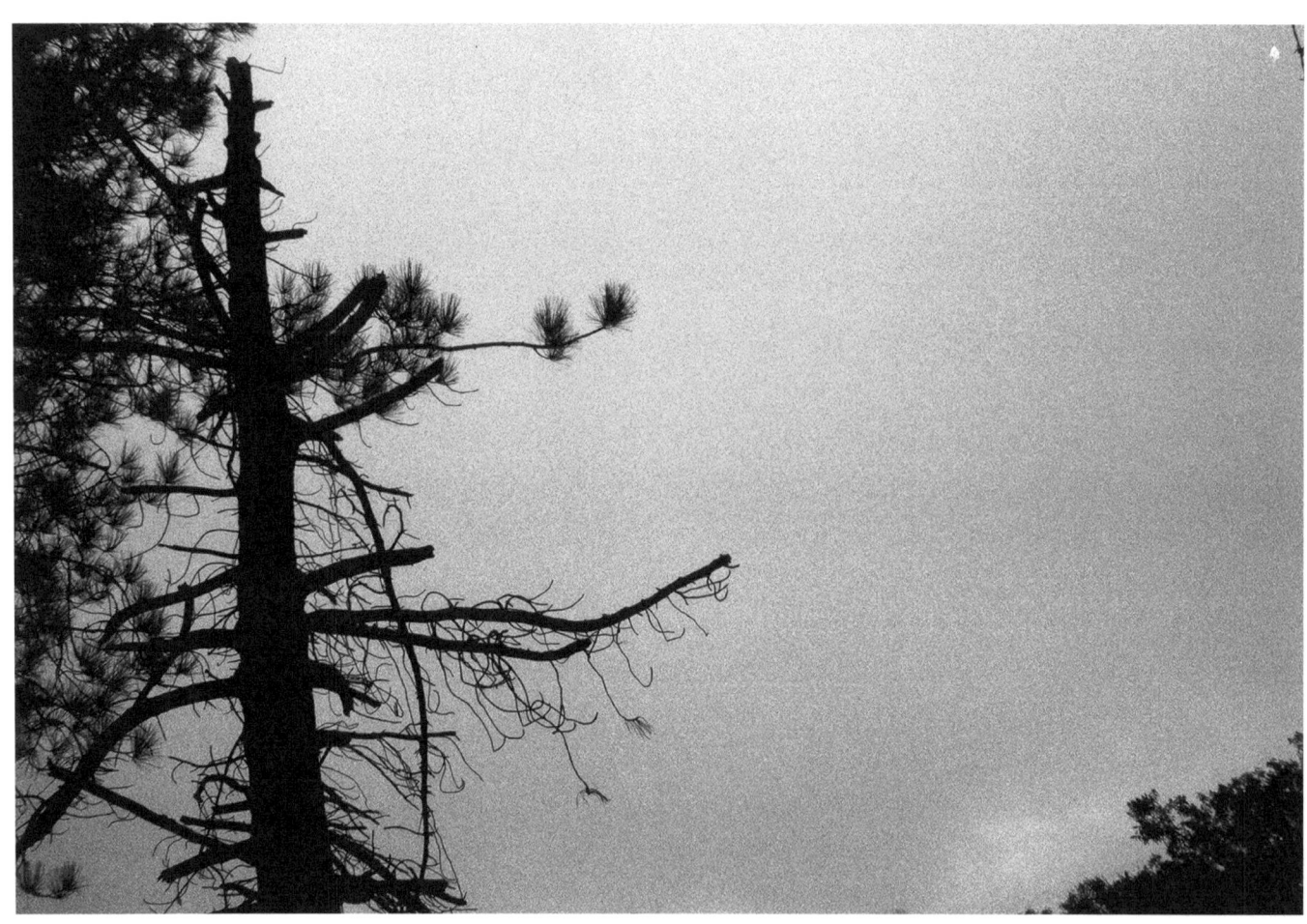

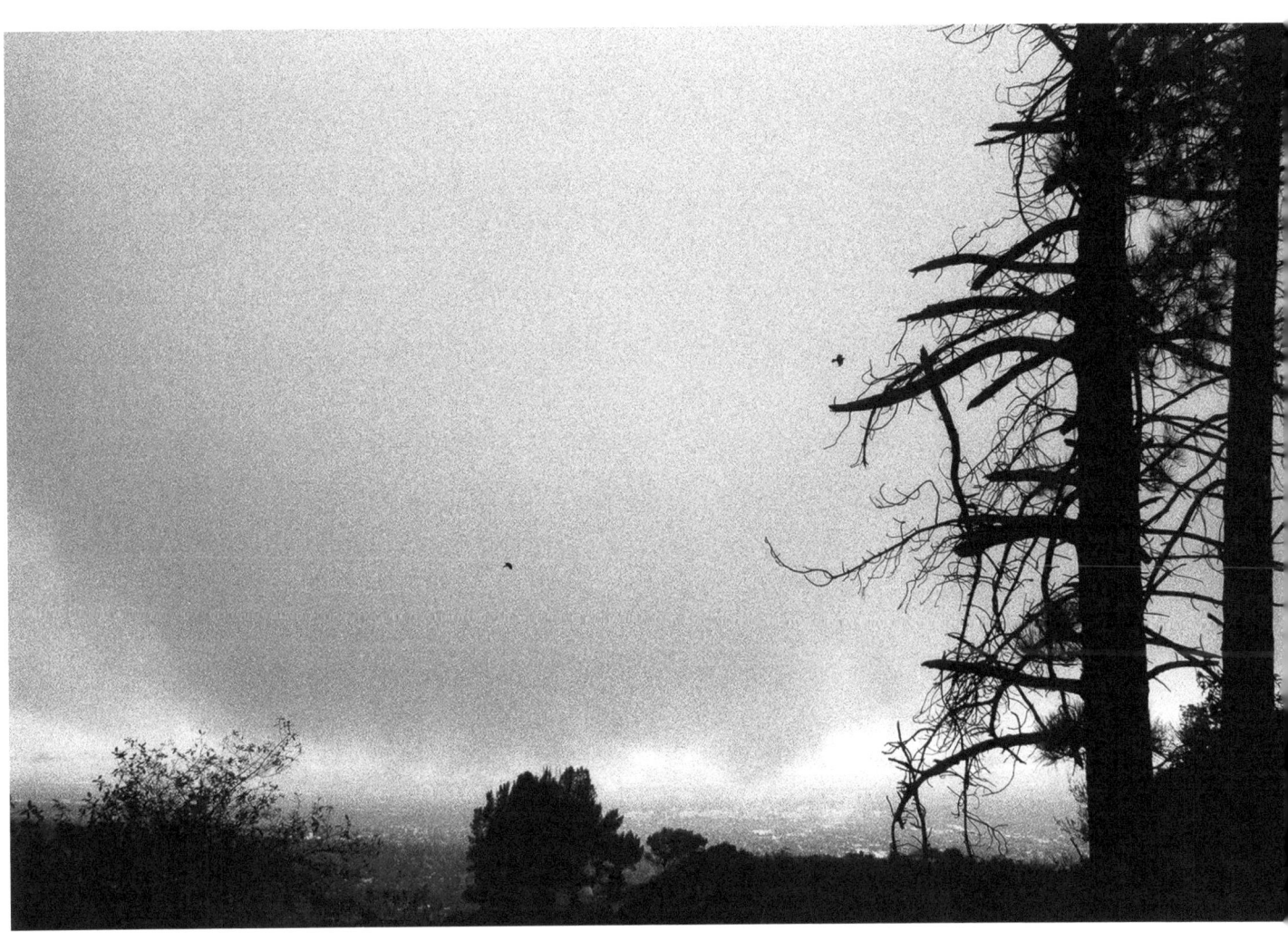

Right: EXCHANGE -- The need to believe in something more.

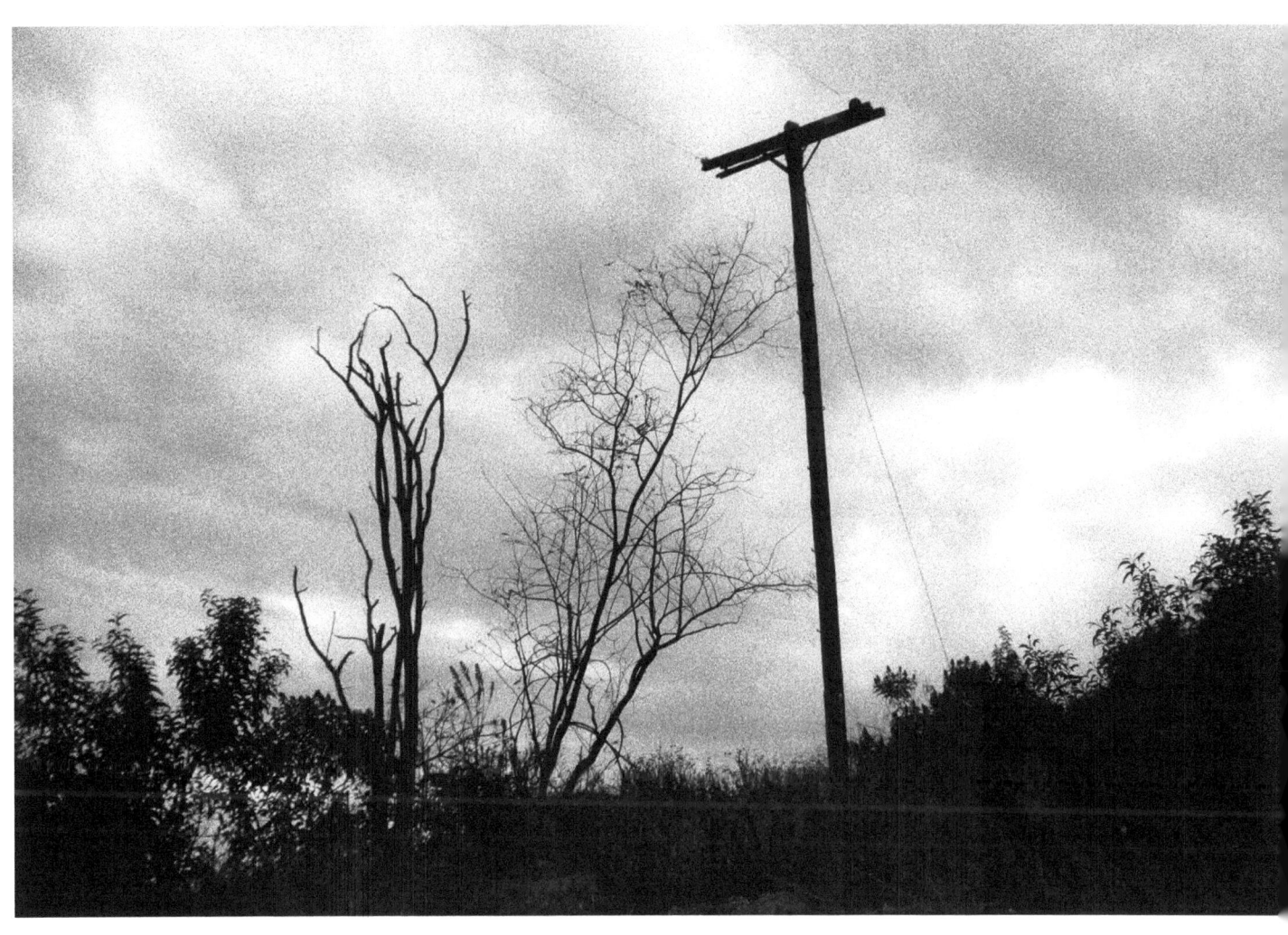

cabin fever - snow in the (757)

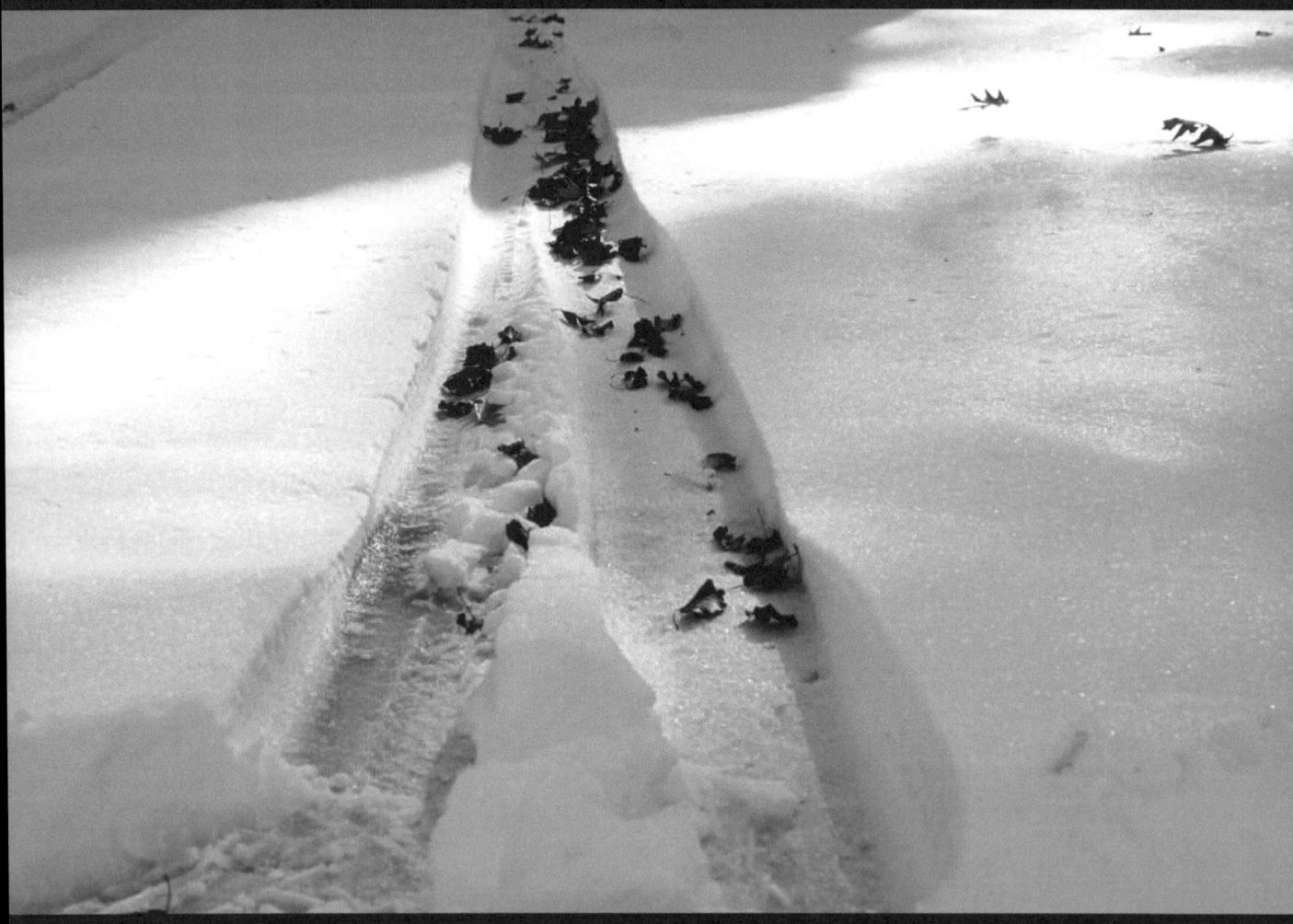

Left: SNOW (To n' Fro)

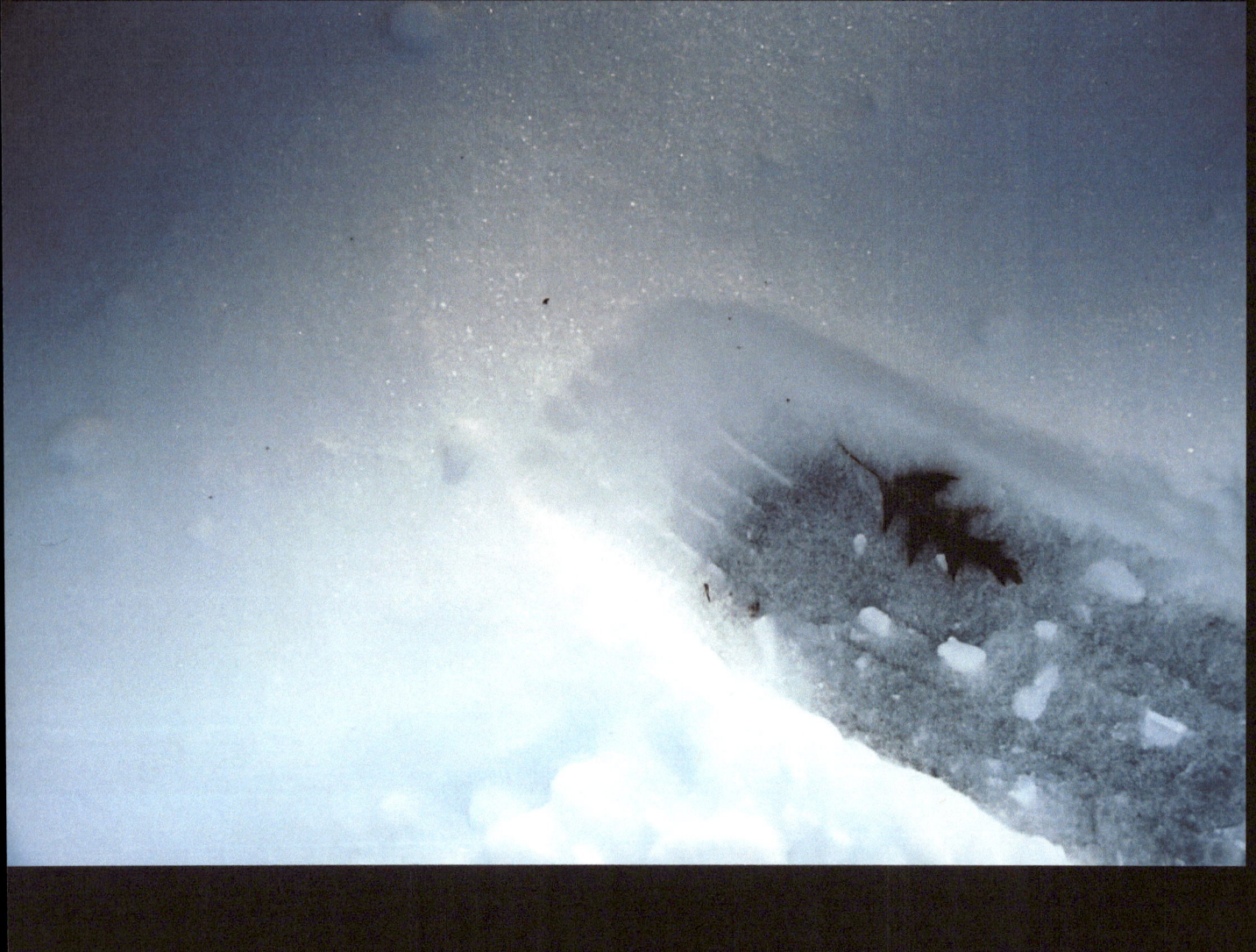

Left: SNOW (Interrupts Rest) -- Unfair. Beauty sometimes needs an advocate.

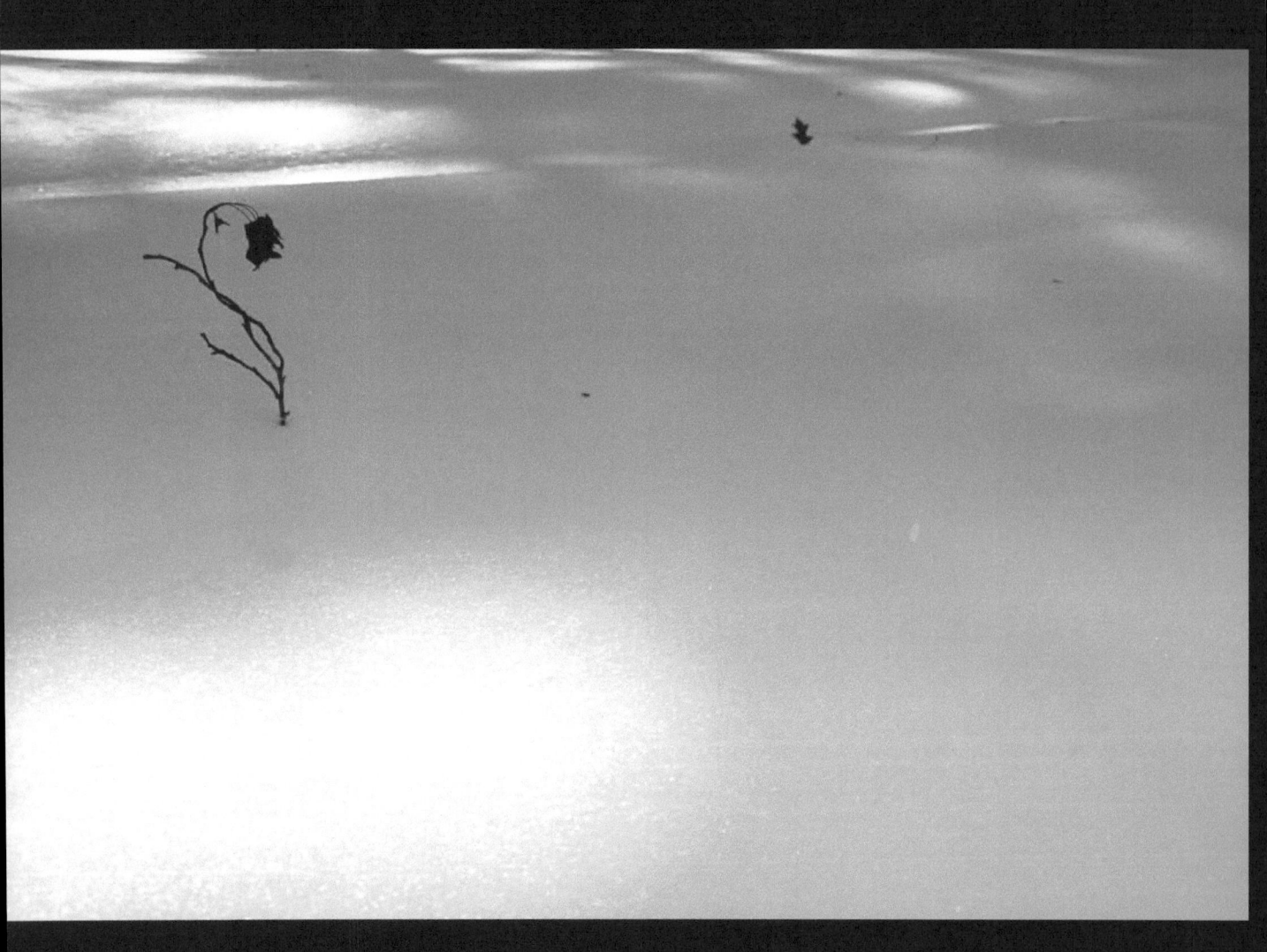

Left: SNOW (Boundaries) -- Beauty and strength can be found in death.

Right: SNOW (Bathe) -- Contrast gives a voice to the silent. Awake... absorbing everything... open to anything. Transparent.

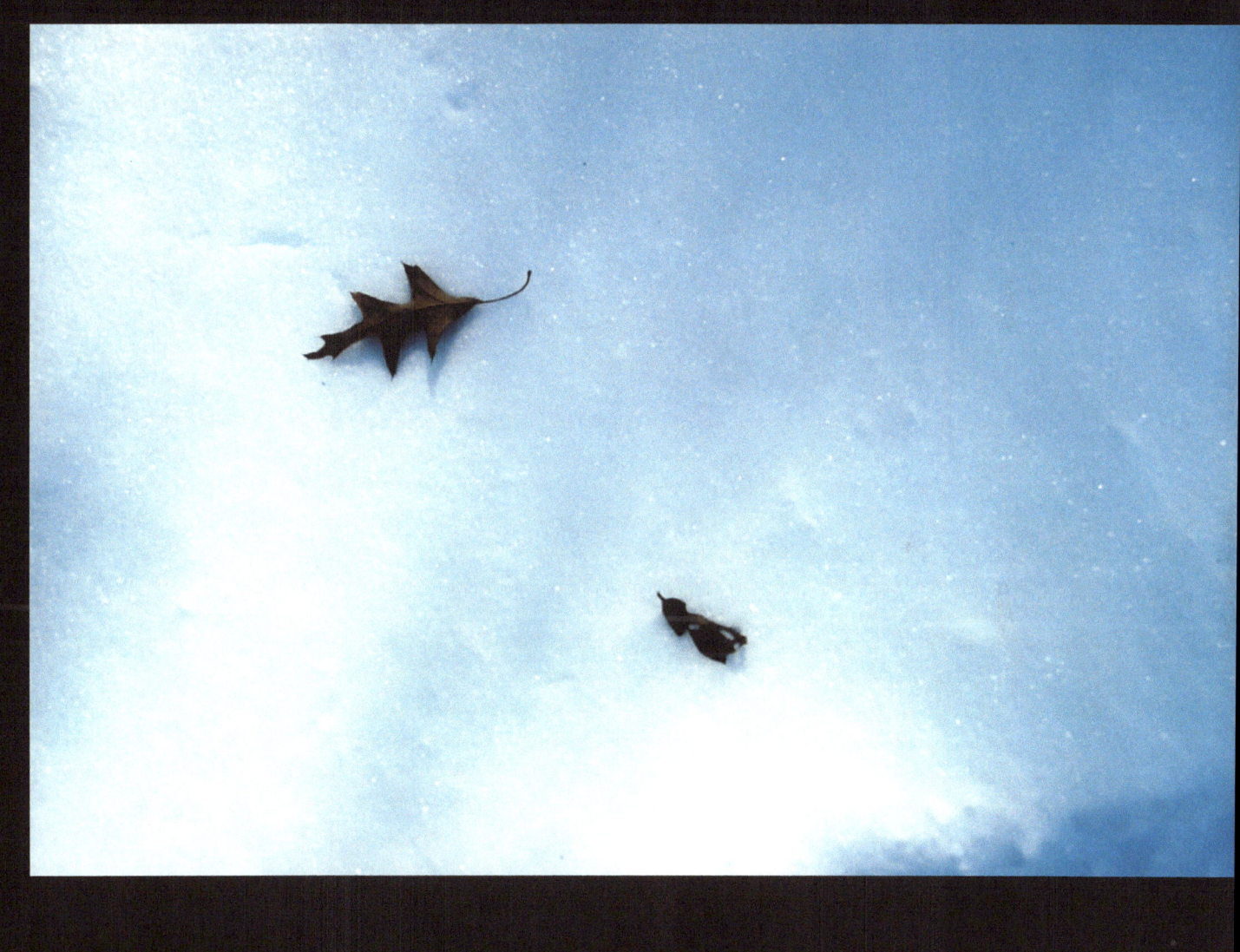

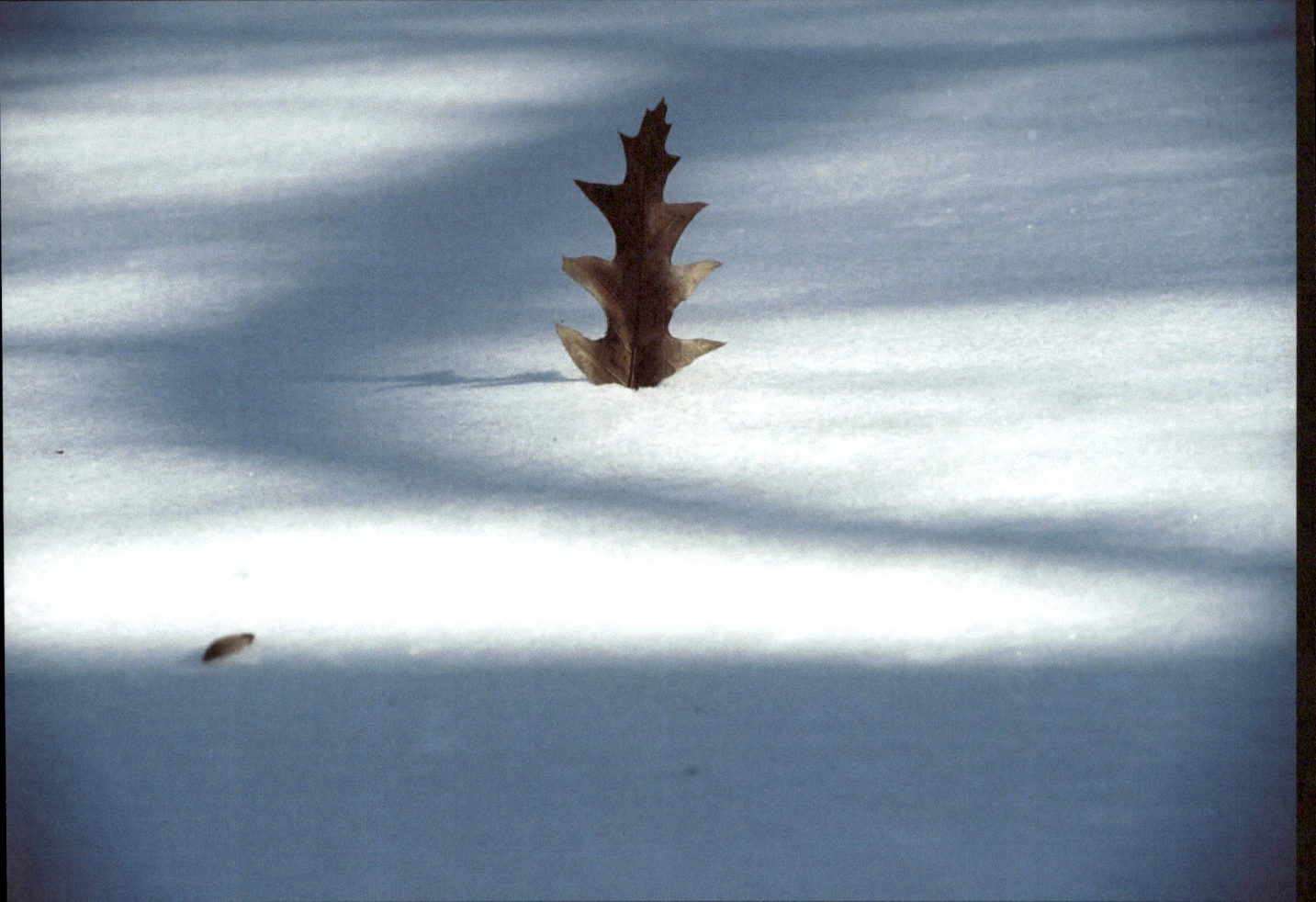

Left: SNOW (Right Here) -- A call for attention.

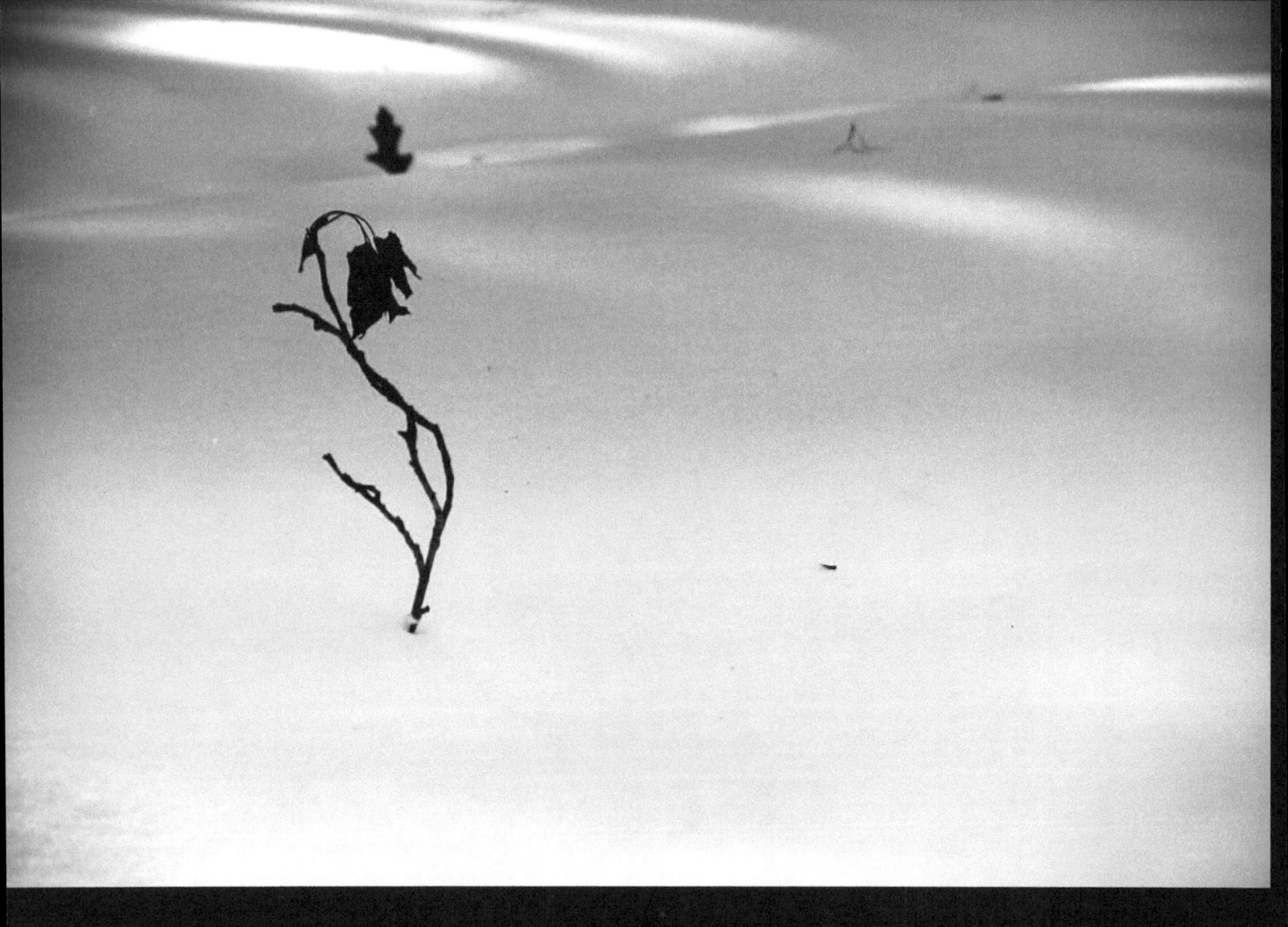

Left: SNOW (Beauty Abandoned) -- Unmet expectations... a closed ear to comfort. Bitterness disguised as strength. And it didn't have to be this way. Time has gone.

Overleaf: SNOW (The Elder) -- Time has gone by... but strength remains.

Right: SNOW (Shelf Life) -- Darkness in elevation. Lower levels of light to give way to life. Perceived safety in the shade is really some of the strongest weakness ever found.

Overleaf: SNOW (Fold) -- No where to go... just give up. The inner voice of fear wins in what looks like a desolate circumstance.

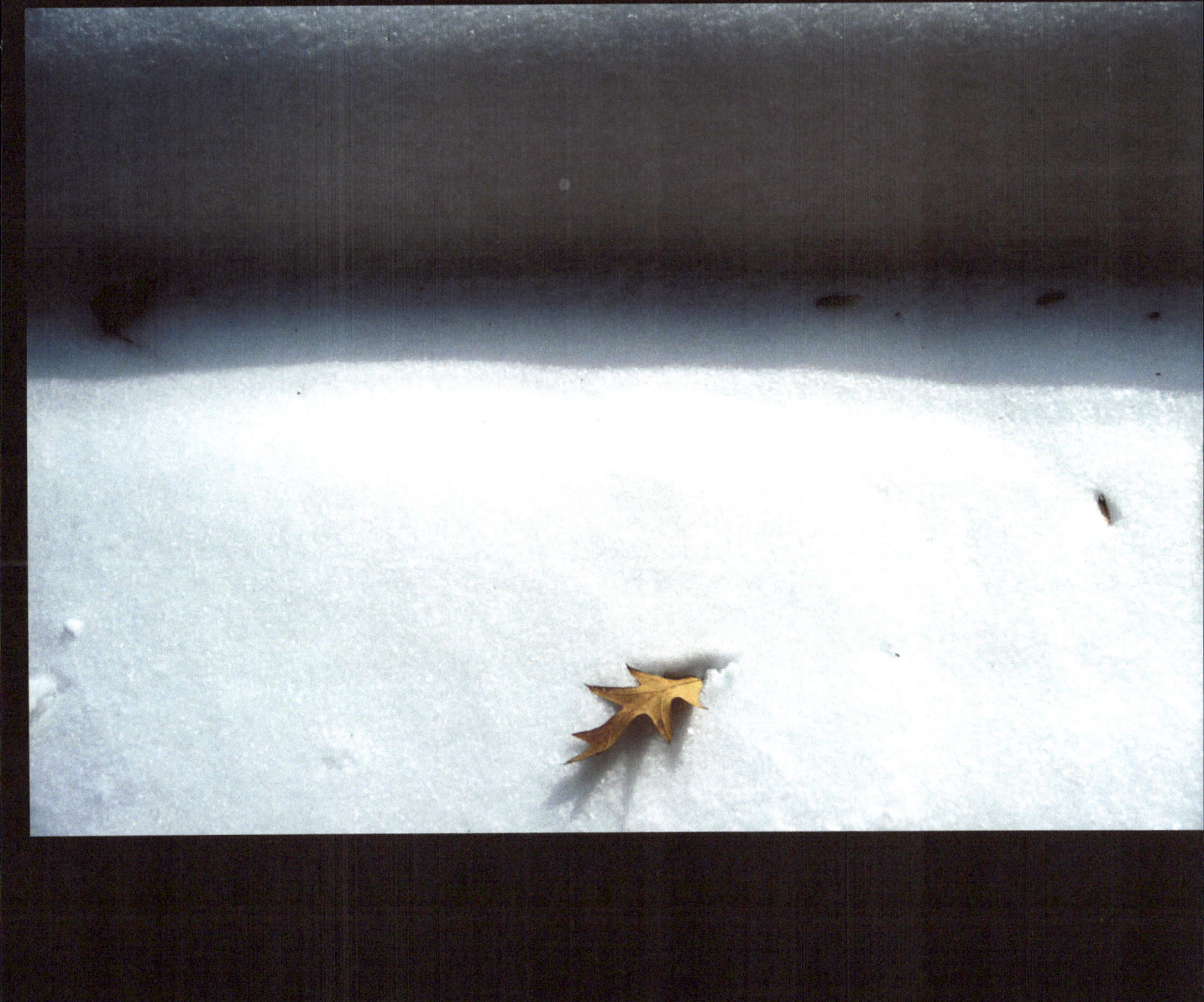

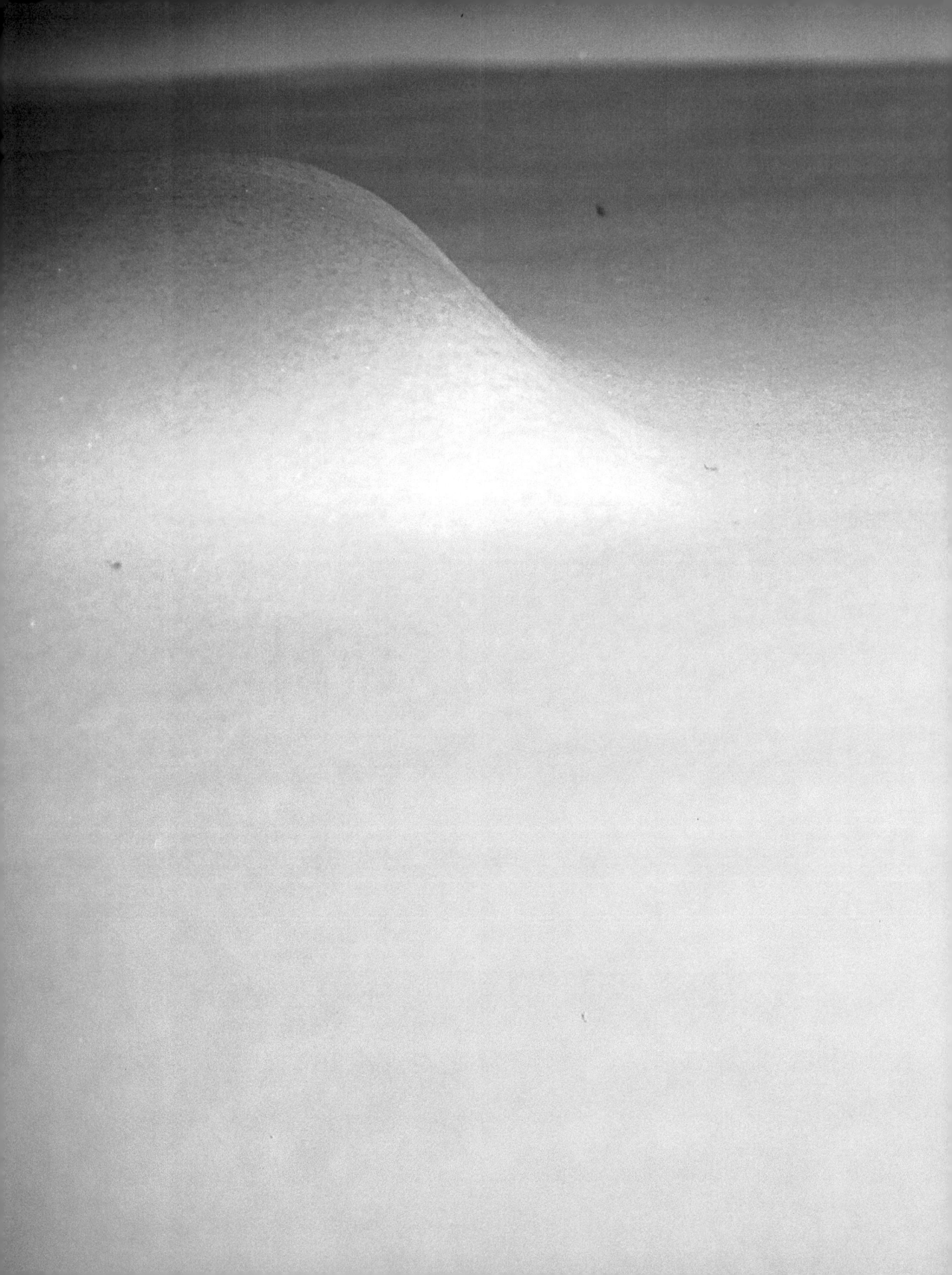

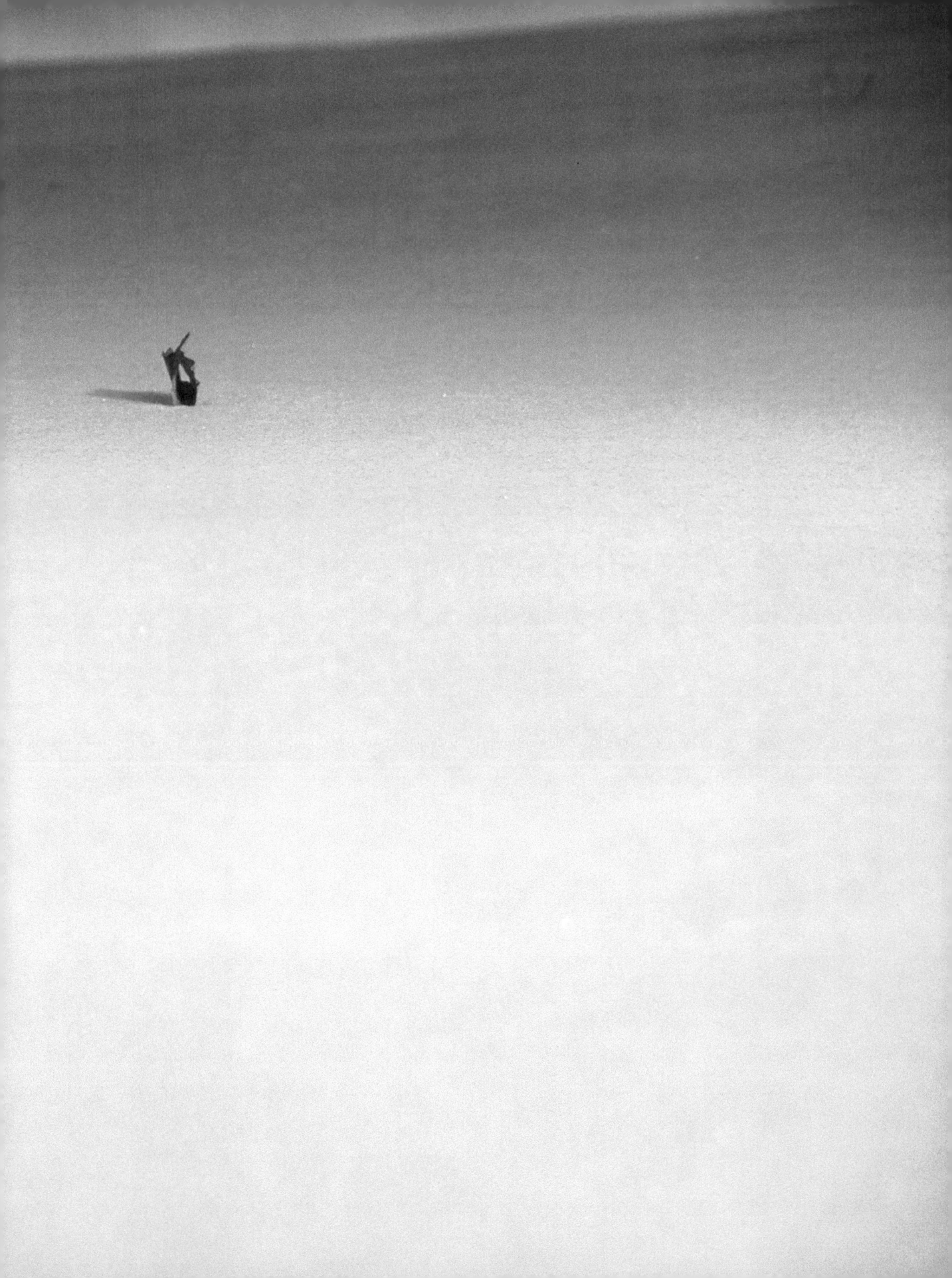

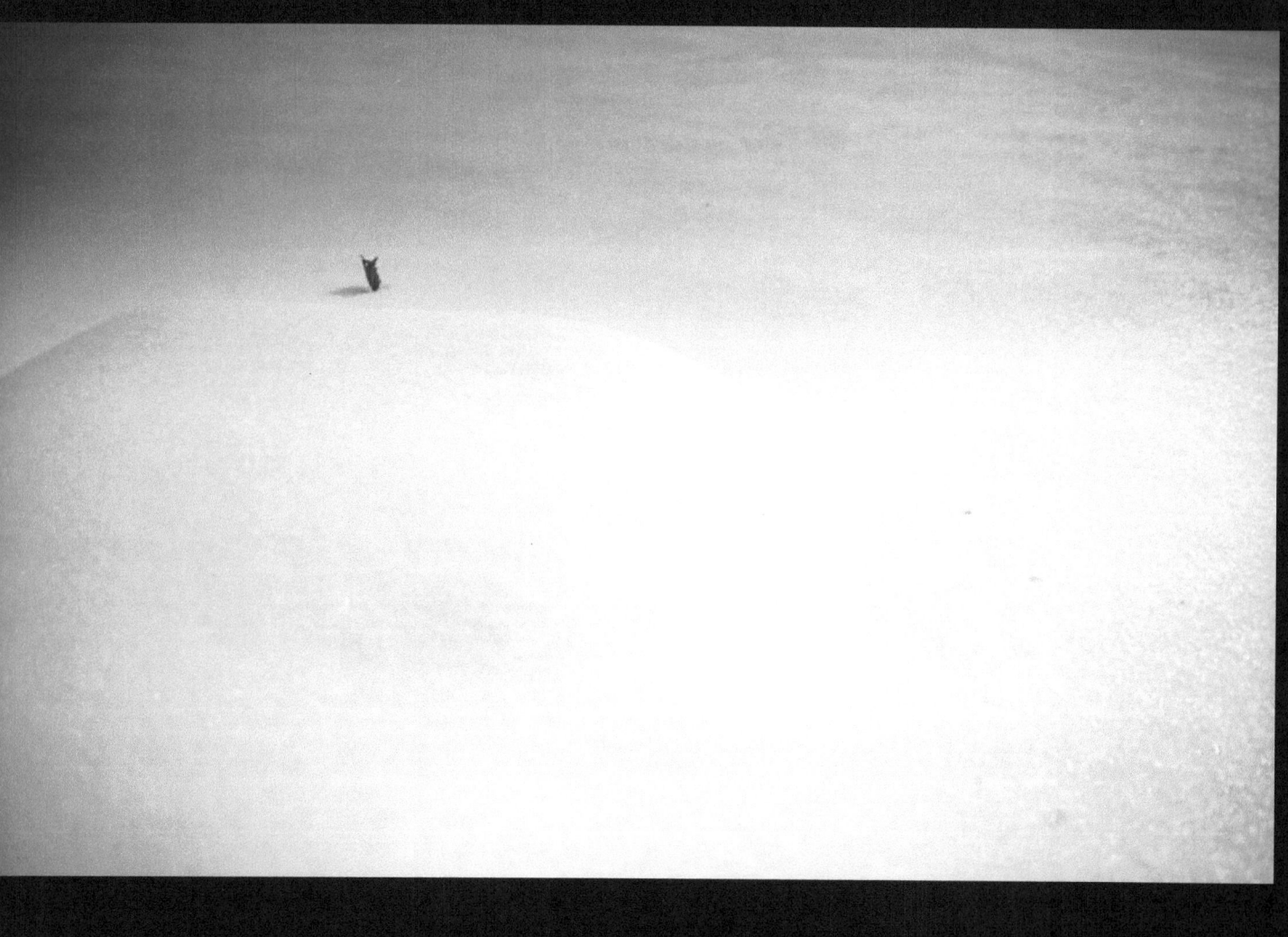

Left: SNOW (The Advantage) -- Dangerous higher ground.

I would like to acknowledge the love and genuine support of my parents DeForest & Deborah, as well as Tony & Tisha, DeMonica, Kevin, Nevin, Justin, the Mapp and Yarbrough families, Rhonda & Chukes, Sandra Holt, Lawrence James, Paula Roberts, Ruby Martin (RIP), Venita Roberts (RIP), and my kindergarten teacher Miss Harris.

DEFOREST

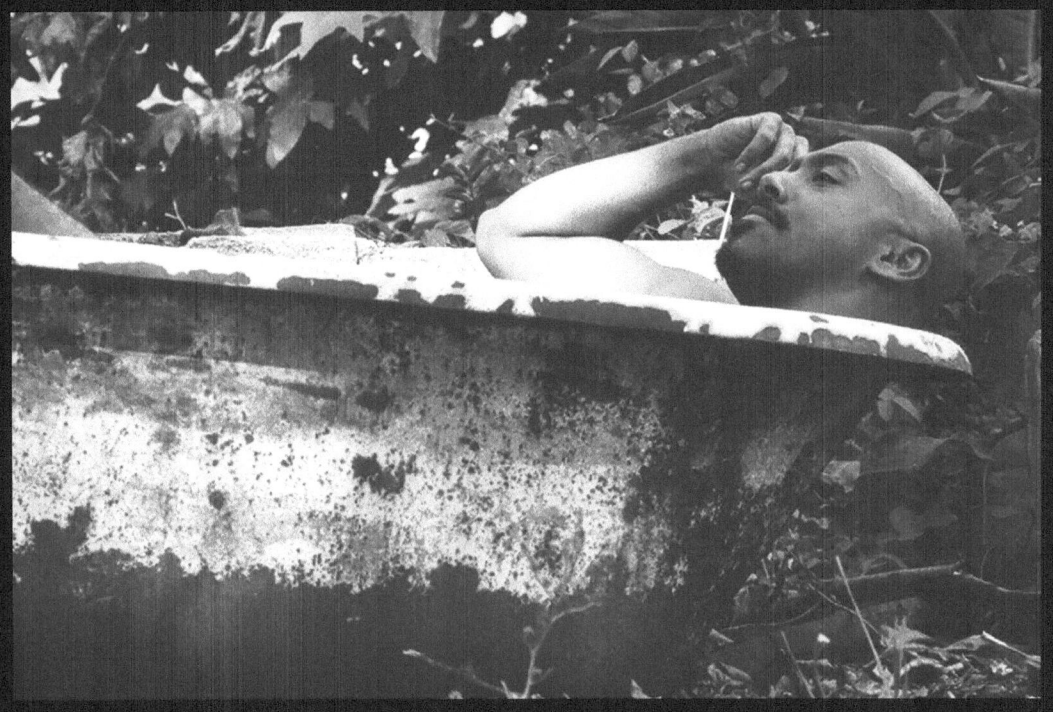

DeFOREST was born in Norfolk, Virginia... at a time where African Americans were beginning to reclaim power among their own individual classes and race. DeForest moved from the Tidewater area to attend Tennessee State University where he received both a BS in Architectural Engineering and a Masters in Business Administration. Since then, "D" has given himself permission to pursue happiness through his core giftings: Acting, filmmaking, and music. *"Sense of Psyight"* is a still image exploration of DeForest's commitment to finding the relationship between the internal and external.

www.ingramcontent.com/pod-product-compliance
Lightning Source LLC
Chambersburg PA
CBHW051018180526
45172CB00002B/399